DRAWING Comfort

for

Chronic Conditions

written and illustrated by

Evie Lennon

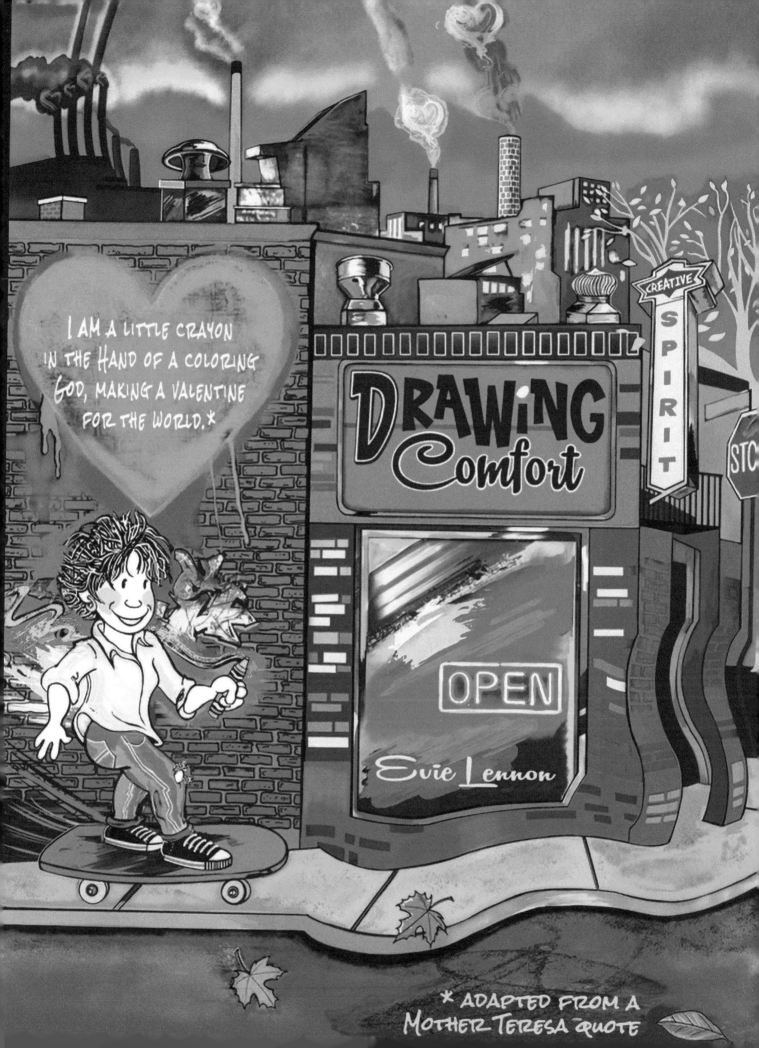

Praise for Evie Lennon's Approach

"Evie Lennon is a capable chaplain with a generosity of spirit and heart. She utilizes her ecumenical spirit, compassion, and humor in ministering and is deeply open and accepting of others. She is not one to simply give "lip service" in this regard but lives it out in her professional life as well as her personal one.

"Lennon celebrates the diversity and differences which others bring to life's experiences and relationships. I have experienced her as being a bridge and an inspirational model for all of us. Lennon has blessed and enhanced the work and mission of the department with her beautiful paintings and drawings.

"Her intuition and listening skills serve her well in discerning the emotional and spiritual needs of others. Evie Lennon is especially observant and gifted in her provision of pastoral care to hospital staff and has been a leader in unifying and encouraging many of the staff. She has demonstrated the ability to gain their trust and confidence."

S.G. Pepper, DMin., BCC, ACPE
former Supervisor, Chaplaincy Coordinator
Children's Metropolitan Hospital

"Our mother, Sophia, had open-heart surgery in January, but developed complications after surgery, and had to return to the hospital numerous times. Evie Lennon listened compassionately, not just with her ears but with her heart. Evie has an amazing, almost sixth-sense ability to communicate with people. She offers solace just by being in the same room. Evie makes you feel comfortable without ever feeling crowded or overwhelmed."

Jill Russo
Patient Family Member
All Saints City Hospital

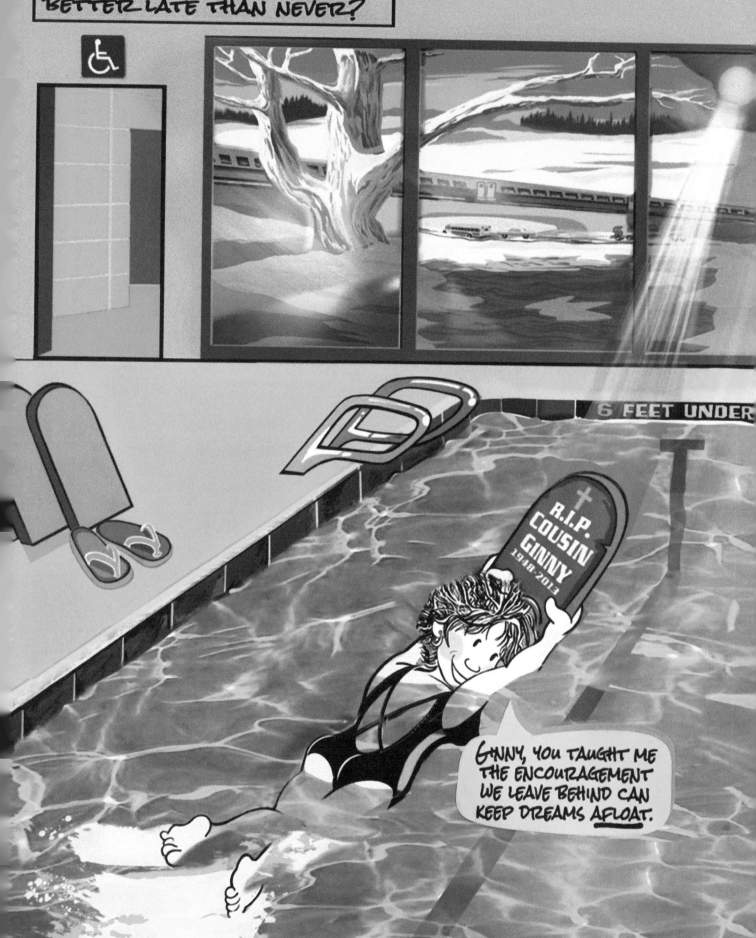

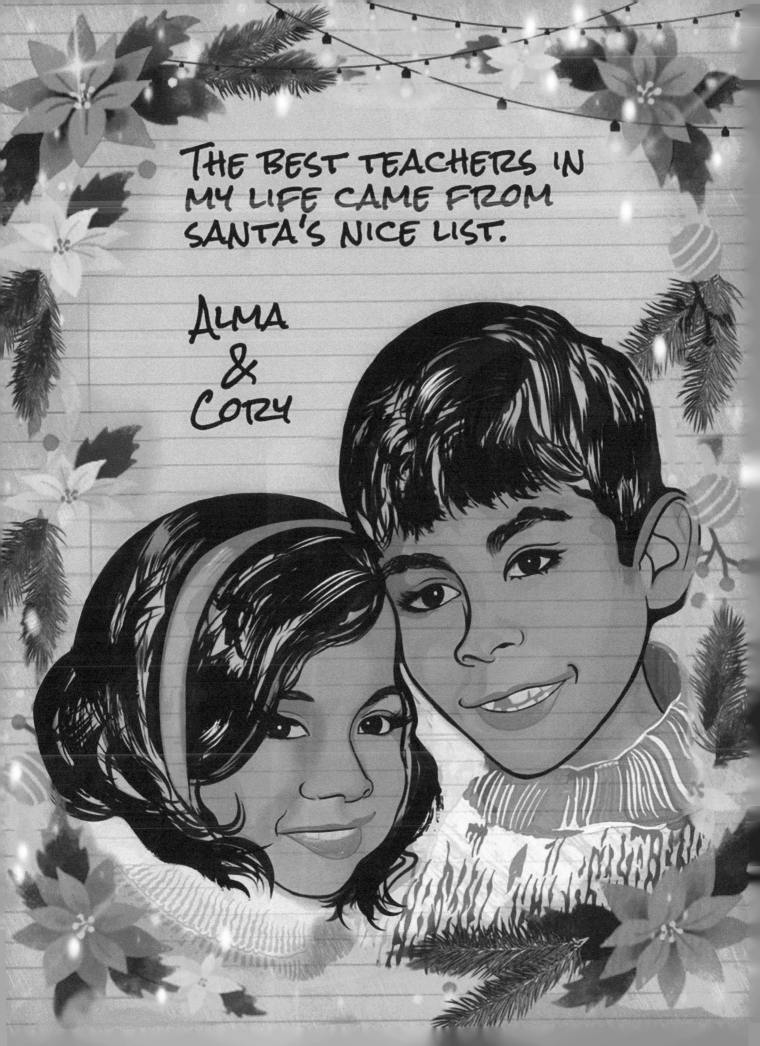

Acknowledgments

My greatest teachers were profoundly medically challenged children I've had the privilege to love, not only in the schools and hospitals where I worked but in my home. My children's wholeness and beauty were so evident that when I later became disabled myself, it was impossible to buy into the myth of inferiority perpetuated by our culture.

"Alma" is the Spanish word for "soul," and "corazón" means heart. My daughter, Alma Mater, and her brother, Cory (Corazón) Spondent, are, in name and in spirit, the heart and soul of this book. My daughter Alma plays on one of the top wheelchair basketball teams in the nation, but what I am most proud of is how Alma champions other people.

Alma has kept her humor and compassion intact, through countless surgeries and endless adversity. Cory has faced equally formidable odds, and the purity of his heart can brighten the darkest day. Due to circumstances that were in place long before I met Cory, he was adopted by another family but holds a permanent place in my heart and life. Although another child of my heart, the late Helen Wheels, never found the understanding she longed for, I hope these pages somehow vindicate her restless heart.

Before anyone knew what Post Traumatic Stress Disorder was, my two deceased uncles, both World War II veterans, were a stone's throw from living on the streets. Their combat continued long after they were back on U.S. soil. They sought refuge from bombs no one else could see by diving under the bed and into the bottle.

Although they were often mistaken for being homeless, my mother insisted that I show them respect. Without knowing it, my mom prepared me to serve people who sustained wounds in a different kind of battle. My mom is my hero for teaching me that heroes are often, to borrow the words of Mother Teresa, in a distressing disguise.

Mom also taught me to never give more credence to another person simply because of their wealth, position, or status. As those things were stripped from me during my disabling illness, those values insulated me from how deeply our societal worth is tied to class, title, and ability. I am nothing but proud of my working-class family who manned the fire and gas stations, factories and mills, bakeries, and ice cream shops in my hometown. If I felt inclined to wear a collar to express my calling as a chaplain, I suspect it would be blue.

Back in the 1960s and 1970s, my teachers also reinforced the dignity of each person. These Catholic nuns wielded guitars instead of rulers in the fight for social justice that was sweeping the nation. They dedicated their lives to providing better access to food, clothing, shelter, and healthcare for the vulnerable. I pray these pages are imbued with the humanity of their music and work which is so needed today as medical battles impoverish the spirit and threaten the security of every level of society.

**"It's a long road to freedom, a winding steep and high,
but if you walk in love with the wind on your wing,
and cover the earth with the songs you sing
the miles fly by."**

-Medical Mission Sisters, lyrics from *Long Road to Freedom,* 1966

These pages would not be here to turn if not for two friends, Colette "Applehead" Panchot and Ella Quint, who have each been a lifeline in the truest sense of the word. They never wavered in supporting me throughout my family's medical ordeals and never stopped holding the vision of my dearest artistic aspirations.

Because of Colette Panchot and Qat Wanders, I now understand why people thank their editors. Qat Wanders put an end to comma placement as random as a *Pin the Tail on the Donkey* game. Qat also gave me the courage to take off the blindfold to see what I could do. That my life's work materialized is also because of Colette Panchot, who retrieved what was best in this work. She created smooth contours from the rough edges with the discernment and artistry of Michelangelo's chisel.

I thank Crystal F. Clear, Bo Hemian, and the Spondent family for helping me find my stride as a parent when both my illness and the bias that followed, shook me to the core. My cousin Houston is the big sister I always wanted and the valiant health warrior I never wanted her to have to be. I hope this work uplifts her as much as she has buoyed me.

I am grateful to the rest of my chosen family, outsider artist tribe Fuji Tiv, Melvis, and Hans, for "kidnapping" me and excavating the most preposterous version of myself. That Cassie Nova, my longtime muse, saw treasures in what they unearthed, fueled my work for years. Last, but not least, I thank God for Home Skillet. To borrow the lyrics of Sir Elton John, I "could roll around the globe and never find a warmer soul to love."

If I have learned anything by being adopted, it is that we are not bound by blood. Neither my daughter nor mother are biologically related to me, yet I feel they are flesh of my flesh and bone of my bones. I'm equally convinced the lifeblood that runs through my veins came from singing nuns. It is perhaps for these reasons that I did not pursue a career in biology! If I leave behind a legacy, let it be from those who shaped me, who are in the very weft and weave of this book.

The author uses the cartoon character Lucky Starzinsky, throughout the book to narrate her points. Lucky considers herself a "Cartoon Therapist," because

A. She *is* a cartoon of a person dispensing counsel.
B. Lucky endorses cartoons as a form of therapy.

Although Lucky Starzinsky derives a lot of pleasure from being the top Cartoon Therapist in the nation, please keep in mind that Cartoon Therapy is a field that Lucky made up herself and that she drew her own credentials. Any advice of a medical, spiritual, or psychological nature, dispensed by a cartoon should be received with discretion and cannot take the place of professional guidance.

As far as the rest of this volume is concerned, please keep in mind that the only thing that is real is love.

Table of Contents

Cast of Characters

Alma Mater- the daughter who teaches by example

Applehead- the friend who is true to the core

Bea N. Bonnet- the agitated school principal

Bo Hemian- the hippie mentor

Cassie Nova- the friend who plays the field

Cory Spondent- the pen pal and former stepson

Crystal F. Clear- the friend without a filter

Dr. D. Klein- the withholding doctor

Dr. Drew A. Blank- the doctor without answers

Dr. Hardy Tuggs- the oral surgeon

Ella Quint- the quintessential poet friend

Fuji Tiv- the friend on the lam

Gail Lantly- the brave Chronic Health Hero

Gerry Riggs- the co-parent and a handy builder

Grace Period- the understanding landlord

Hans- the fabled painter friend

Helen Wheels- the troublemaker child on a motorcycle

Home Skillet- Lucky doesn't kiss and tell

Houston- the cousin who has a problem

June Frost- the Chronic Health Hero who feels unwelcome

Lee Way- the dry cleaner who gives Lucky discounts

Les S. Moore- the English teacher who over-edits

Lucky Starzinsky- alter ego author of the art journal

Marion Nette- the boss's puppet

May Day- the Chronic Health Hero in distress

M-Dawg- the roommate also known as the Moon

Melvis- the celebrity painter friend

Miss Construe- the paranoid human resources director

Mom- the wind beneath my wings

Olive Branch- Alma's stepmom and family peacemaker

O. Mitted- the disabled job applicant who is skipped over

Otto M.- mutiny causing pirate who steals health

Pat Answer- the corporate spokesperson minimizing able-ism

Robin Peter- the impoverished Chronic Health Hero paying Paul

Roger Wilco- a patient on his way out

Rue Merz- the loose-lipped gossip

Rick O'Shea- the friend that deflects concerns

Shell Schokt- the shaken Chronic Health Hero

Val Yent- the brave support group facilitator.

Introduction: A Lucky Draw
Dealt a Bad Hand? Creativity and Humor: A Winning Pair

May I become at all times, both now and forever,
A protector of those without protection,
A guide for those who have lost their way,
A ship for those with oceans to cross,
A bridge for those with rivers to cross,
A sanctuary for those in danger,
A lamp for those without light,
A place of refuge for those who lack shelter,
And a servant to all in need.

-excerpt from a prayer by Shantideva

Although I have never met most of you, the thought of you kept me reaching for my pen when I wanted to give up. What I felt in those moments was love and a desire to affirm those of you who have been hurt by people who could not, or would not, hear the alarms telling you something was very wrong.

This book is designed to help people from all walks of life who happen to be dealing with a long-term illness or injury. As I humbly share my own experiences, it is my deepest honor to serve people who have a *wide* array of traditions, backgrounds, and orientations. The belief that *is* non-negotiable to me is that the quality of your life is *sacred*.

I became a chaplain because my life made me a student of loss. I lost many immediate and extended family members when I was young. Mourning those losses, along with my clinical pastoral training and experience, enabled me to spot the grieving process in arenas we don't traditionally associate with loss.

If you picked up this book because you've been going through a health situation for some time now, I want to tell you, with as much love as I know how, that you are going through losses that are multiple and profound. Whether or not your situation is the result of disease or disability, whether you were born with it or acquired it, whether or not you have a diagnosis, and whether or not it's terminal, the series of traumatic blows you have likely had to withstand deserve to be recognized and respected.

I wrote this book because I care that you are going through grief without the spiritual and emotional support that should absolutely be in place for losses of this magnitude.

Throughout this book, I share stories from my chaplaincy experiences because whether we are letting go of another person or facing a series of profound changes, the grieving *process* is the same. The deepest well of wisdom I draw from though is the one I share with you as a Chronic Health Hero. I thought I already knew something about endurance until my thirty-day medical leave became a permanent one.

Getting seriously ill on the heels of adopting my profoundly medically challenged daughter brought the battle of my life. In fact, this writing first began as a children's book because I wanted Alma to understand that the invisible forces that created obstacles for us were no reflection on my love for her. However, the adversity we braved together left me little time to illustrate the storms Alma couldn't see. By the time we could take a breath, a decade had passed, and sadly Alma was already experiencing the bias I had couched in story form.

In spite of having a more visible disability, Alma had her own unseen struggles. In fact, Alma noted that her wheelchair often obscured her individuality, reducing her to a poster child. Because Alma is so much more than her situation, her harrowing tale isn't my primary means of communicating the struggles all of us often face. Although I share my experiences as a mom whose illness affects my journey as a parent, Alma's story is hers to tell.

Whether our condition is visible or invisible, Chronic Health Heroes want neither our personhood nor our situation eclipsed. Both forms of dismissal lead to more emotional pain being heaped onto the suffering we are already experiencing. We may underestimate the impact of these misperceptions and responses because they are often conveyed without malicious intent. Yet, the cumulative effect of these exchanges can easily snowball into a "Code Blue" for our spirits.

In this book, I identify twelve major areas of life where chronic conditions can result in loss and devote a chapter to each one. The art prompts, or "Creative Sparks," in each chapter are designed with proven methods to help you process those specific losses in your own way.

So what's the benefit of approaching the fallout of long-term disability and chronic disease as a loss? Because loss without expressed grief extinguishes our spirit.

The grieving process can be an empowering and beautiful dance that enables the spirit to be renewed. It's a dance Life required me to learn intimately, and I believe in its healing power.

CREATIVITY

When my health fell apart, my career, marriage, finances, family, and social life quickly followed. I needed something to hold onto, and I found just what I needed: a crayon.

Having a creative outlet salvaged my spirit when I felt my very spark was about to be extinguished! Please know you don't have to draw *well* to draw *comfort* from the arts. In fact, the more rudimentary "sketches" often help us the most, whether they are scribbles, jotted notes, or a spontaneous skit. In fact, it's that very sense of playfulness can help you drop the defenses that can hinder healing because it's pretty hard to be pretentious while you're holding a crayon or colored pencil. Of course, you are free to let go of confining ideas whether or not you ever do the activities described in this book. The last thing I want you to feel is that there is a taskmaster requiring you to make "art."

"Creative Sparks" offer *options* such as writing, drawing, and drama because people gravitate toward different art forms. It is also okay to deviate from the directions provided here. They are meant to be used as springboards, not approached like mid-term exams. I didn't even follow my *own* directions when I was making a sample project for chapter two and ended up having an emotional breakthrough just the same.

There are a couple of dozen Creative Sparks you are free to choose from, but luckily it *isn't* homework. Wanna give it a try?

CREATIVE SPARK #1: "GREATEST HITS"

While thinking about your health journey, look at a music playlist, whether it's your collection of vinyl records or your Spotify library. Select a song title that jumps out at you. Don't worry if it *logically* fits your situation; your subconscious will connect the dots for you when you write or draw whatever springs to mind in your art journal.

Although *straightforward* journaling about my life alleviated some sorrow, adding the element of *imagination* took it to the next level. The phrase "spark the imagination" is no coincidence. Creativity seems to tap into a divine spark. Writing a poem or making a picture can be as sacred as attending services in a cathedral, temple, or mosque.

Another phrase that speaks to the spiritual power of imagination is "the redemptive power of storytelling." Blurring the lines between reality and imagination liberates us from the endless explanations that leave us drained and agitated. Weaving a little "tall" into our tales eliminates the "burden of proof" that plagues so many of our conversations.

Works made in the Creative Spirit soothe with velocity.

There are times when rehashing the actual events of the day hold as much appeal as sticking pins in our eyes. I will be encouraging you to use artistic license by sharing samples from my own art journals and providing you with correlating activities in the Creative Sparks sections. Imagine what an *escape hatch* a diary would become if you wrote it as an alter ego! In fact, it's time for me to introduce you to someone. Meet Lucky Starzinsky!

Lucky is a fictitious character I created to help tell my story. When Lucky's parents were killed in a go-cart race, she was adopted by a well-meaning but dysfunctional clan of Polish/Irish/Native-Americans. The "Starzinsky" name reflects the "environmentally Polish" piece of her upbringing. Other aspects of Lucky's identity are intentionally open-ended because, in addition to delegating my art journaling to Lucky, it is my hope that she can serve as a universal underdog for the diverse group of people who are on a health journey.

Her skin tone is also left blank because I was physically unable to bring myself to fill Lucky Starzinsky in with the light peach color that is too often unconsciously selected to characterize "person," because it is a practice that excludes so many. While differences such as race, gender, orientation, or creed profoundly enrich and inform our outlooks and identities, the author hopes that everyone feels a little bit "Lucky."

Lucky is joined by an equally playful cast of fictional characters that I hope you enjoy spending time with.

When you enter the world of imagination, you'll discover details you are compelled to include or exclude. These inclinations offer fascinating clues about what you hold dear. When author Maggie O'Farrell was interviewed on NPR's "All Things Considered" about her historical fiction novel "Hamnet" based on Shakespeare's son Hamlet, she said she resisted writing writing it until her son celebrated his eleventh birthday. Hamlet died at the age of eleven. Superstitious or not, O'Farrell's maternal instinct won out over expediency. You may discover your own priorities in the next activity.

CREATIVE SPARK #2: "A LUCKY STAR IS BORN (OR ADOPTED)"

Whether or not you know it, you are the hero of your own story. Let yourself create an alter ego who will narrate your stories and pictures. Draw or describe your inner hero, and name him or her. By seeing ourselves on paper in a parallel universe, we can offer the same clarity and tenderness we more easily grant to others, to ourselves.

Although I've been involved in using the arts as a healing tool for more than thirty years, I am still stunned by the powerful channel art provides to our subconscious mind. When I share the heartbreaks or breakthroughs I've experienced or witnessed, it's not my intention to make you sad. What I want you to know is that *your* stories can unlock liberating realizations.

Once, when I was facilitating a workshop for teens who had lost a parent or sibling, I handed each person a random page torn from a paperback novel. I had literally grabbed the book on my way out the door. (If you do this exercise at home, please be sure it's *your* book *before* you tear out the pages.) I asked the teens to circle a word or two to jumpstart a poem about losing their family members.

One young person circled the phrase "missing tooth" and wrote that her smile was always self-conscious after her mother died. Like a person with a missing tooth, she attempted to hide the space left by her mother's absence. Like a tongue compulsively returning to the space that's left, her mind kept returning to the hole in her heart. In a final poignant note she added, "And like a missing tooth, my mother can never be replaced."

Creativity is not only an opportunity for us to *convey* ideas that inspire others, but it is also an avenue for the artist to *discover* truths that revive ourselves.

When I refer to refreshing our spirit, I am speaking about the human spirit that can be rekindled through the spark of imagination. Creativity can connect us to our "higher self" or unearth our basest animal instincts.

Lucky Starzinsky said there were times she *sounded* like an actual animal. When her tears morphed into what could be best described as howling, Lucky fibbed and told her upstairs neighbors she was enjoying an *Animal Planet* series about coyotes to cover her tracks (pardon the pun.) More than once, Lucky heard the dog upstairs join in! We can only hope no one hears the tears we cry when we're alone in bed, or for the more extroverted among us, in aisle seven of the grocery store.

Lucky eventually became too sad to even howl when she entered what she referred to as her "post-Neolithic period." She feared that *even* if Josh Groban serenaded Lucky at her apartment while Oprah made her a cup of tea in the kitchen, she would still feel down! Drawing that scene in her art journal made Lucky laugh. As she did more exercises in this book Lucky was like a Phoenix rising from the ashes, (*if* the bird took an elevator and stopped for naps on the even-numbered floors.)

Art gives us *permission* to color outside of the lines. Lucky Starzinsky decided to portray her trainwreck of a life as a shipwreck simply because she liked boats better than trains. That fictitious ship, and the stories that ensued, transported Lucky out of a hopeless place.

CREATIVE SPARK #3: "HERO'S JOURNEY"

Draw a fictitious vehicle of transportation that has carried you so far. Are you traveling by air, sea, or land? There is no such thing as a wrong choice; it could be a rusted-out Buick, a magic carpet, a space vehicle, or whatever strikes you. Is anyone traveling with you in your mind's eye? Has anyone disembarked? Have any new passengers jumped aboard?

No matter which mode of transportation you choose, it can bring you closer to peace. There is a joy in learning about your own inner workings. Questions like, "What can I learn from this?" "What is true for me?" and "What do I most want other people to know?" enables you to identify, honor, and act on what you are experiencing.

HUMOR

As a chaplain, I can tell you there is one thing you can always count on when things seem unbearable: Someone will say the stupidest thing you can imagine. Some people won't *ever* "get the memo," even if you *literally* draw a picture. Noting the madness will deepen your *own* appreciation for the grit your journey has required. And of course, having a chance to draw yourself with a perfect butt and great hair can boost your spirit and self-esteem too!

Although this book is laced with humor, the uplifting power it contains is no joke. As someone who has arrived on the scene to say, "I respect your situation," the use of humor may seem like a contradiction. Keep in mind that cartoons and comical sketches are a form of social commentary.

The minute you laugh at something that diminishes you or the gravity of your situation, you diminish the *hold* that those indignities have over you.

Humor is in fact, a spiritual practice in some Native American cultures. The Lakota Sioux considers the role of the clown so sacred, one is only eligible for this role if they receive a vision of a thunderbird. The person who plays this role uses comedy in this tradition to create clarity about emotional weaknesses. Notably, the clown's power to heal comes from distressing events in their own lives.

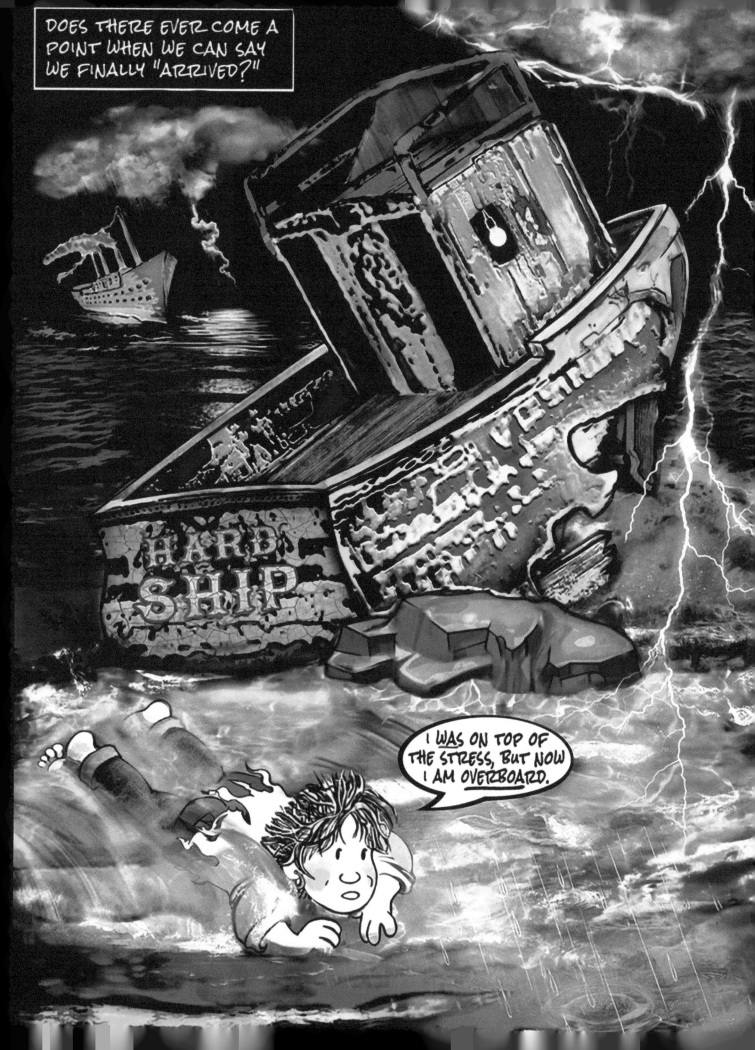

When Anita Moorjani wrote *Dying to Be Me* after a near-death experience, her advice after her visit to the after-life was this: "If I ever had to create a set of tenets for a spiritual path to healing, number one on my list would be to laugh as often as possible throughout every single day. This would be hands-down over and above any form of prayer, meditation, chanting, or diet reform."

There will always be people who think you are okay as long if your mailing address isn't a cardboard box. When the sister-in-law, who is perplexed as to why you skip meals to afford the shots you need, volunteers to vaccinate endangered sea lions in the Arctic Circle, the spiritual practice of laughing can preserve your sanity. I'm not suggesting that we start slapping our kneecaps at the silent Buddhist retreat or add handlebar mustaches to every self-portrait. I am suggesting we make laughter *one* of our healing venues. If you have a chronic condition, a sense of humor and a little imagination will go a long way.

I know it isn't always easy to laugh. Situations that require epic fortitude sometimes draw indifference instead of support; challenges that warrant admiration and encouragement often elicit scrutiny or criticism instead.

For some reason, our society honors certain losses while failing to recognize others. Some of the noblest battles are fought in isolation, while others go viral and capture the hearts of millions.

It is partly a mystery and partly conditioning at work, and I'll talk about both as we create together. A lot has transpired since I began this work with my hand outstretched to you. And I've been reaching for you ever since, inviting you to step into the circle with others who share your unseen battles and unsung beauty. I know you'll find the warmth and comfort you have always deserved. Join me on a magical journey through the absurdities of life.

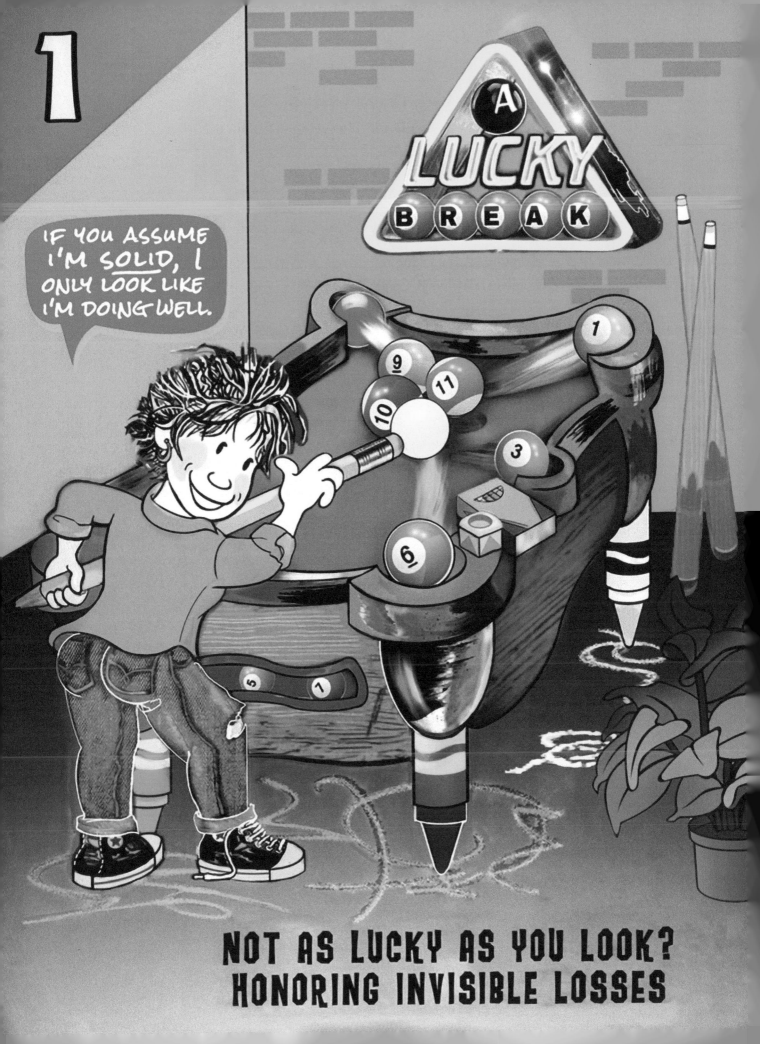

Chapter One: A Lucky Break
Not as Lucky as You Look? Honoring Invisible Losses

"Speak your mind even if your voice shakes."
-Maggie Kuhn

One of the traumatic losses faced by Chronic Health Heroes is diminished credibility and influence. Every minority group knows that even giving voice to the struggle itself is met with resistance. Sadly, there is a reason the disabled are included in anti-discrimination legislation.

This voicelessness isn't just something we encounter in institutions. Often the key players in our lives do not align themselves wholeheartedly with our search for solutions. In spite of the obstacles that continue to stand between us and the life we envisioned at this juncture in our lives, our attempts to garner empathy are sometimes batted away, like a child's dirty hand reaching for the candy dish.

Culturally, there is often an involuntary and even compulsive need to ignore, dismiss, or diminish the suffering of Chronic Health Heroes. I consider this to be a very real pathology in our society.

Broaching the subject of our conditions seems to trigger an interrogation about food choices, exercise habits, and meditation practices. Suspecting that medically challenged people have uniformly brought on their dilemmas through poor lifestyle habits is akin to incorrectly linking race to criminal behavior. For the person with a disabling condition, the need to fend off the constant interrogations is not only offensive but a discouraging roadblock to our healing process.

"My heart is a prison of 'Have you tried?' Have you tried exercising? Have you tried eating better? Have you tried not being sad, not being sick? Have you tried being more like me? Have you tried shutting up? Yes, I have tried. Yes, I am still trying, and yes, I am still sick."
-Emm Roy, *The First Step*

It feels bad when someone implies we might have been spared something as devastating as Leukemia or Crohn's Disease or Clinical Depression, if only we had been spiritual or health-conscious enough. In fact, issues like lethargy and exercise intolerance are often an *indication* rather than a *cause* of a medical problem. While lifestyle choices are undeniably powerful factors in health, it does not negate the need for investigating a medical problem that may be time-sensitive.

Many chronic illnesses are complex and won't be resolved with a single diagnosis. Being diagnosed at the Mayo Clinic with Sjogren's Syndrome was only a first step in my health journey. Following up with a rheumatologist back home, I was told the form of Sjogren's I had was a rare, serious subset of Systemic Lupus that could lead to organ damage.

It is naive to assume that taking a natural approach eliminates the need to be evaluated by traditional medicine.

Traditional and alternative medicine aren't mutually exclusive. Insulin is naturally occurring in the body but administering an unneeded shot could kill someone. A lot of my regimen involves replacing enzymes and hormones my body no longer makes because of complications like hypothyroidism and chronic pancreatitis. No matter how organic substances are, guesswork about what your body needs could be lethal.

It would be years after my initial diagnosis from Mayo Clinic before most of the fallout was diagnosed and treated. In the meantime, I received a combination of dismissal and folksy mottoes in response to my symptoms. My left foot was so swollen, it looked like I had stuffed a Cornish game hen in my left shoe, but I just smiled and nodded when people suggested exercise would resolve my weakness and shortness of breath.

I'm glad I pursued answers since the culprits turned out to be pulmonary hypertension, chronic diastolic heart failure, paroxysmal supraventricular and atrial tachycardia, requiring a team of cardiologists and a pulmonologist. There was a reason I felt less inclined to hit the gym, but I appreciated the 29 people who suggested it all the same. Now my exercise program is sanctioned by my doctors and empowers rather than endangers me.

"If I had a do-over, I would spend less time trying to convince people why I needed to get to the Land of Oz, and more time on the Yellow Brick Road!"
-Lucky Starzinsky

CREATIVE SPARK #4: "OZ"

If you were off to see the Wizard, what would you be seeking? What other magical tale captures your quest for health? Draw or write yourself as a character in a classic play or movie. Who are the antagonists?

Caring for your mind and spirit is not a woo-woo luxury. It's vital. Spirit fuels the ongoing pursuit of answers for the physical manifestations of your situation. Cultivating a strong spirit isn't intangible;

it creates precious stamina to act on your own behalf. That momentum increases the odds of finding accurate evaluations and optimal treatment plans. An illness's longevity doesn't reduce the sense of urgency to dial down the suffering. The need to mitigate discomfort in the long term situation is even greater. Strengthening your own convictions through the arts will safeguard you from being side-tracked in your search.

Keep in mind that our current culture doesn't prepare people to respond to a health crisis. Society gives us clearer expectations about how to throw a bachelorette party than how to show up for surgery. Schools are more concerned with helping us calculate what time two trains will cross paths. I'm *very* prepared if Amtrak suddenly withholds their train schedules, or if I'm ever called upon to identify a trapezoid in a lineup of shapes.

In addition to being unprepared to respond to suffering, research isn't always allocated in proportion to need. The second leading cause of a chronic illness is an autoimmune disease, yet only three percent of the National Institute of Health's current budget goes to this topic. The lack of information about many conditions contributes to the sometimes underwhelming response we receive.

Sometimes our loved ones are more prone to blind spots precisely because they are our loved ones.

People may also play devil's advocate because they don't want to believe anything bad is happening to us. There may also be a part of us that doesn't want to believe it either. It *is* enticing to believe we could just "mind-over-matter" our way around symptoms *until* we bump up against the real constraints again. We often cycle through periods of wishful thinking only to face that the sobering limits are still there.

While it's life-giving to push ourselves in physical therapy, for example, to make incremental gains, engaging in activities that are simply beyond our capacity just doesn't work. Your energy is your greatest resource in this battle. While it is great to give everyone the benefit of the doubt, not subjecting yourself to life-draining insensitivity is important too. Not everyone who questions or resists your situation has misguided good intentions. And sharing appetizers at "Chillie's Cantina" while you hope they clue in, will not bring you peace.

CREATIVE SPARK #5: "DISCONNECT"

Sometimes our interactions can be as shocking as the nightly news. Capture the absurdity of a frustrating encounter by playfully portraying the people who weren't "connecting the dots" as characters from a book.

It's hard when our loved ones challenge rather than share our obsession to get relief. After all, "the winning combination" could potentially give us our life back. If you find yourself experiencing perpetual low-grade anger, check your assumptions about this seeming indifference. Remember that everyone has their own ingrained beliefs and baggage around health. The *origins* of those outlooks run deeper than we might ever suspect, and a chronic condition can send a wrecking ball through our bonds pretty quickly.

What our friends say affects us in part, because of our *interpretation* of why they said it. I'm not saying that there isn't a need for massive sensitivity training in the arena of health in the general population. Still, the stories we tell ourselves can shape our disposition and affect our recovery. While this may sound obvious, translating people's responses through the filter of my own history cost me precious energy. At my lowest points, I misinterpreted other people's behavior to mean *I was not worth saving*, which caused me deep dismay.

When it comes to knowing what goes on in the hearts and minds of our friends, and even in our own psyche, there is usually more going on that meets the eye. Where two people's history collide can be a breeding ground for misunderstanding. The best way to avoid conflict is for all parties to be in touch with their own feelings.

Have you heard the saying, "Be kind, because everyone is fighting a battle that you know nothing about"? Although many of us feel this slogan should be justifiably tattooed on our ass, it applies to other people too, no matter how carefree their Instagram feed appears. It may seem like our distress should be obvious because we are *in* our bodies where the threat is felt, but the view might be obstructed by their own consuming circumstances.

Because we are wired for survival, we instinctively attack anyone perceived as standing in the way of relief. Channel those emotions to eradicate barriers that stand between us and solutions, rather than tear apart the bonds we share with well-intentioned friends.

Resist the temptation to become a pain snob.

A Chronic Health Hero named May Day bounced concerns about her declining health off of her best friend Rick O'Shea only to have him deflect her distress signals. When May learned she actually had Lyme Disease, she was *ticked* that Rick O'Shea had ricocheted her complaints, and hurt when he failed to check up on her. It turns out that Rick might have needed someone to check up on him as well.

Rue Merz, Rick's older sister, told May that Rick had been going through a crisis as well. When Rick was laid off from his job, the uncontrollable fear of germs that had plagued him as a child resurfaced. Rue Merz disclosed that in elementary school, Rick was forbidden to watch the television show, *General Hospital*, because each time he saw it, he was irrationally afraid of acquiring a clubfoot or contracting malaria.

19

The lay-off led to him being diagnosed with an Anxiety Disorder. When it got back to Rick via Rue Merz that his friend May had been upset, he called to reassure her that he had only wanted to protect May from the hypochondriacal anxiety that plagued him. The moral of the story is don't make assumptions about other people's assumptions, (assuming that you are.)

CREATIVE SPARK #6: "MESSAGE IN A BOTTLE"

Remember, feelings aren't facts. We can't know why people react the way that they do. Yet the messages we take away from our interpretations still impact us. Draw several "abstract" bottle shapes on a blank piece of paper and write the negative messages you receive surrounding your chronic condition inside of them. Seeing these messages spelled out helps you not "bottle up" this internal dialogue. Whether people say hurtful things because they have issues or if they are just being jerks, you don't have to take it in. Taking an inventory helps us clean house.

As much as we'd all like to believe our ordeals have turned us into a saint like Mother Teresa, we can be unaware of the trials of someone right next to us. Everyone has such different virtual reality headsets strapped to their heads, it's a wonder anyone can communicate effectively at all.

It's been very humbling to see my own blind spots around other people's disabilities.

I realized belatedly that the late Helen Wheels had likely sustained traumatic brain injuries as a child. I treated many of her symptoms as a bad attitude when she was alive while congratulating myself for a disposition I now realize is a privilege. When it comes to combating able-ism, the unconscious supremacy of able-bodied people, it is important to not get so deeply entrenched into an "us vs. them" mentality that we overlook someone else's potential struggles.

Don't be in a rush to call in the judge and jury for a final verdict on friends you cherish. While it's tempting to let frustrating interactions propel you further into conflict, keep moving forward on your own behalf. I say this having failed to follow my own advice. Sequester your inner jury until you can deliberate from a more centered stance. Your frustration is urging you to retreat from any situation that detains you from the task at hand, which of course, is your health.

What can be particularly devastating is if someone becomes enraged in response to our vulnerability. Any explosive reaction may signal an unaddressed trauma of their own is being triggered by your situation. The volatility of their reaction is likely due to events or situations that happened long ago and possibly before you knew each other. While it is important not to misinterpret things that hit us the wrong way, it is equally important to deflect projections.

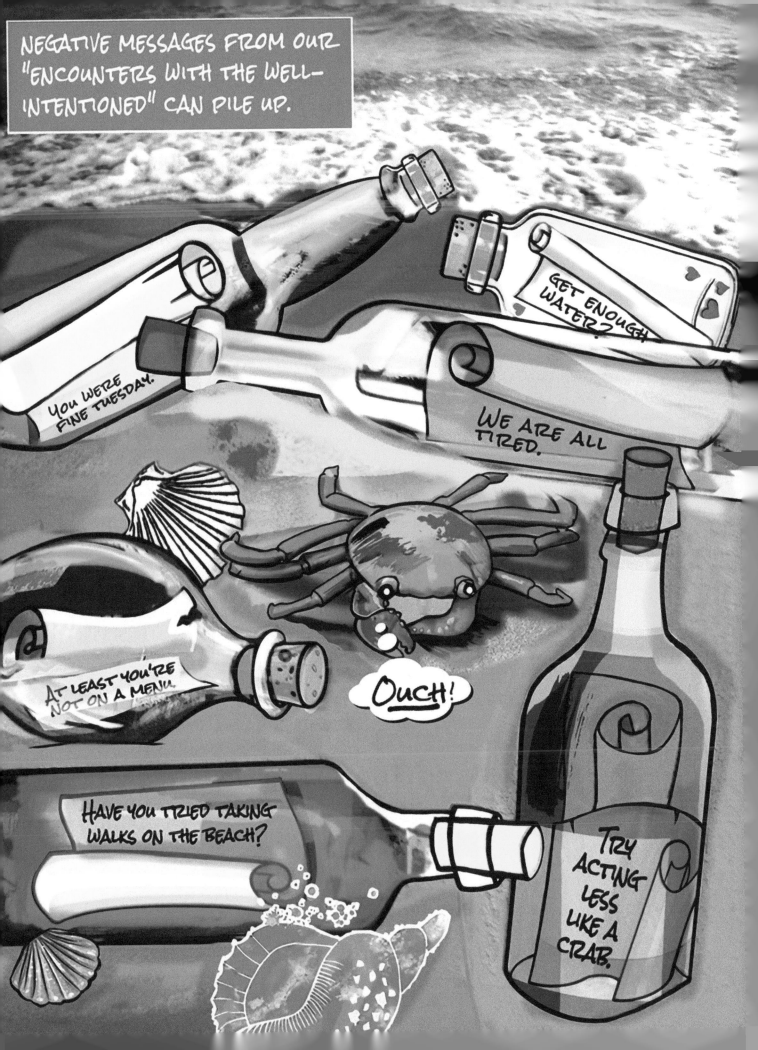

If the person in your life is in the role of caregiver, consider that their own physical and emotional vulnerabilities are being exacerbated by the ongoing stress. Honoring their limits is paramount too. Caregivers often die before the identified patient because they sometimes start ignoring their own well-being. No one needs to be silent about their needs. Healthy relating is about give and take and creative problem-solving.

There may be times you are the only one around to encourage your own ass. The silver lining of these "desert times" is that your self-talk is *the* voice that will most powerfully influence your psyche. So be sure you speak to yourself with kindness.

My cousin Houston has learned a lot about staying encouraged. Several years ago she had some lab work done. When the results came in, the doctors said, "Houston, we have a problem." Namely, she had a rare liver disorder called A-1 that required a transplant. Houston's body rejected the liver, and now she needs a kidney transplant too, in addition to open-heart surgery that her body wouldn't be able to tolerate.

Yet Houston refuses to budge off the planet. She is alive, in part because of an ever-evolving treatment plan. Her doctors' approach reminds me of the dramatic rescue devised by the Apollo 13 ground crew when the spacecraft's heat shield, oxygen, and fuel supply were insufficient to return the astronauts safely back to earth. Their ingenuity in overcoming those barriers was so extraordinary a movie was made about the mission.

In one scene, a NASA engineer instructs an astronaut to rip the flight manual cover off, roll it up, and secure it with some duct tape to replace a cylinder that had malfunctioned. Houston is so determined, I wouldn't be surprised if she tried putting office supplies in her body. It might explain why the Scotch tape always goes missing every time we go to wrap a present.

As tough as Houston is, she had this to say about the human part of the equation, "I was most surprised with how I was treated differently with my illness. You find out who your true friends and family are. I was also surprised that the ones that were there for me were not the ones I would have thought. I also found that most people think that if they don't ask, they can pretend it does not exist. It hurts, but I handle it. I only tell things to the ones who ask. My advice is to get a grip on everything yourself and cling to the ones that care."

Houston, you are dealing with your problem!

Chapter Two: A Lucky Guess
Spinning Your Wheels for Answers? Solving the Puzzle

"Courage does not always roar. Sometimes courage is the quiet voice at the end of the day saying, "'I will try again tomorrow.'"
-Mary Anne Radmacher

When those closest to us unwittingly discourage the very advocacy we need to gather critical information, there are a lot of societal pressures and personal dynamics at play. One myth at play is that as long as you don't have cancer, you are okay. Most people also operate under the assumption that any truly serious illness would be easily spotted and pinpointed by a doctor.

The average autoimmune disease takes five years to be diagnosed, meaning someone could wait sixty months for support. Hopefully, the information in this book will help people with any kind of undiagnosed disorder reduce that timeline.

When Dr. Atul Gawande was a surgical resident, his young son needed surgery. Dr. Gawande quickly saw that current medical theories and technologies are only helpful if they are well-utilized. When he first noticed the discrepancies that inspired his book, *Complications*, he made an educated guess that one to two percent of autopsies would reveal misdiagnosis as the cause of death. Dr. Gawande learned the figure was closer to forty percent!

Those rates of detection have not improved since about 1938, according to pathologist George Lundberg, former editor of the prestigious *Journal of the American Medical Association*. I don't share these statistics to disparage doctors and nurses because I have witnessed some of the most heroic measures working in emergency departments and hospital ICUs. I saw my coworkers' quick thinking save life after life.

Many of my colleagues cared deeply to the extent that they brought their work home with them, sometimes in the form of anxiety and sadness. One nurse had a nightmare that all the streets in his neighborhood were named after diseases. In his dream, he told himself the street names made sense since he lived near the hospital. To me, it showed that he was thinking about his patients at every turn (literally) on the way home from work.

Medical personnel is neither gods nor ogres. Many chose their professional path for noble reasons, but the industry's structure doesn't always allow doctors to reap the benefits of the latest advances. Insurance companies require practitioners to base their orders on the definitive and conventional. And those parameters aren't conducive to the kind of exploration patients with complex symptomatology

fervently hope to receive. The continuous disappointment of undiagnosed patients wears on the health providers too. Constraints and continual questions about their expertise polarize patients and physicians, rather than facilitating fruitful dialogue.

The point is to seek medical services through a lens of realism, which is somewhere between the pit and the pedestal.

Traditional medicine offers many valuable solutions, and it is potentially dangerous to think it is dispensable. It is equally naive to ignore the fallibility of this sometimes intimidating industry. Unfortunately, Chronic Health Heroes default to resignation after many failed attempts for help. While resignation spares a person's humiliation it also precludes the chance for relief.

CREATIVE SPARK #7: "UNMASKING RESIGNATION"

Create a mask that reveals rather than hides your true feelings. Use any materials at your disposal, such as paper plates, bottle caps, macaroni noodles, markers, etc. Trust your creative impulses to uncover your deepest truths.

Mask-making has been known to be beneficial for even people with extreme Post Traumatic Stress Disorder such as war veterans. Yet, I was so surprised by the empowering insights I gained when I made a mask, I want to share my discoveries. I ended up following an impulse to embellish a wooden mask I found at a thrift store. I later found myself vigorously gouging into the wood with a chisel, before realizing I was mimicking how much my face got attacked by my disease.

So many symptoms of my disease (and looks of disapproval) had been directed on my face! I had ocular migraines that affected my nose, compromised tear ducts and salivary glands, difficulty swallowing, nauseating throat pain, and missing teeth to name a few. People with Sjogren's are also susceptible to certain cancers, and a large sickle-shaped scar marked my left cheek where a malignant tumor had been removed.

As I chiseled away at the face, I suddenly remembered a news story several months earlier, "Recuperating in Standish," about a kitten who was nursed back to health after his face had been deliberately smashed. When I first came across the article, without understanding why, I drove to the pharmacy to print the photo of the tattered furry face. It was a considerable effort, given it is difficult for me to make it to the kitchen some days. Remarkably, I looked up the article by Cole Waterman days before publishing this and read, "Zorn (veterinarian Dr. Matilda Tammy Zorn) determined he had suffered a broken jaw, broken bones in his nasal cavity, a broken cheekbone, and was missing teeth. He also had an upper respiratory infection.

You can trust the process to reveal gems as time goes on. I noticed the mask had a resemblance to King Moonracer, the protective ruler of Misfit Toys in "Rudolph the Rednosed Reindeer." What kept me fierce during my fight was a desire to help all of us feel at home in this world, especially Alma and Cory. I wonder what your mask will reveal about your ordeal and the new identity you have forged?

"Queen Moonracer"

Because intuition draws attention to things that facilitate our healing, my unconscious zeroed in on uncanny parallels to where my pain was before I even read the article. You can count on that same "flow" that helped me identify with the cat's suffering as well as his innocence. Even physical pain brought about by disease can be experienced as punitive.

Now when I note the change to my appearance in the mirror, I am better equipped to feel compassion rather than shame for what I have weathered. By acknowledging the level of attack I withstood, I was able to affirm that the punishment doled out by both the disease and bias was undeserved. The mask enabled me to nurture that wounded kitten in me into a protective lioness.

"You transform into a tiger before their eyes."
-I Ching, Richard Wilhelm translation

Thankfully, there are people like Dr. Gawande who are working to change the game when it comes to smoothing the long road to recovery. There are over 7,000 rare diseases. The more common diseases can emerge and recede in cyclical ways (usually emerging at home and magically receding once your body senses it has crossed the threshold of a doctor's waiting room). As much as our friends and family want us to find "the answer," it's not a singular event.

As the name implies, systemic disease impacts many systems. Looking at the symptoms in isolation will not help a doctor identify a disease whose hallmark characteristics present in a diverse cluster. In this age of specialization, the laser-focus can come at a cost, even *within* a field. For example, expertise about cutting-edge cancer treatments in a hematology/oncology practice can be at the expense of staying current on blood disorder treatments.

Recognition of this exact discrepancy led patients and physicians to form a powerful partnership. They established a blood disorder support association and mobilized to educate everyone, bridging the chasm between research and practice.

Having more alliances that advocate for doctors and patients alike could reduce the growing dissatisfaction with office visits. Our current medical model may not properly equip doctors to stem the growing tide of chronic illnesses. Nearly every person I interviewed for this book had one or more upsetting interactions with a medical professional who left them feeling dismissed or disrespected. Networking with other Chronic Health Heroes who share this frustration can help depersonalize these affronts to our dignity so we are not dissuaded from finding treatment.

Being allergic to both Plaquenil and Imuran, the standard treatment and chemotherapy drug for my disease respectively, meant not being able to slow its progression directly. Needing to address the resulting complications separately, meant facing more minimization from various specialists.

I encountered "medical gaslighting" for years before I learned the term existed. Naming things, whether it is a disease defining a set of symptoms or a psychological phenomenon marked by a set of behaviors, is empowering.

Over the course of a decade, I was diagnosed with numerous complications; some were minor skin manifestations, others were excruciating before treatment, and several are still life-threatening. Not *one* of those diagnoses fell into my lap. It was worth every humiliating office visit and every eye roll to get answers and relief for *each* situation. The cumulative result is that I have patched together a life that is not nearly as consumed by unbearable pain.

Equally as shocking as the laden quest for answers, was the failure of some physicians to report those hard-won findings once a diagnosis had been made. I only learned about some of my complications, such as a collapsed lung and heart failure because I had to obtained copies of my records to maintain my private disability payments.

Nondisclosure and the subsequent delay in diagnosis and treatment are all too commonplace. *Always* get copies of your medical records.

The purpose of advocacy is to eliminate needless suffering. Doctors often pathologize the anxiety that naturally accompanies the desire for treatment. Disparaging remarks about my pursuit of answers ran like a vein through my chart in spite of positive findings. What doctors don't always understand is that our attachment is having relief, *not* to having a sickness.

When diagnosis and the subsequent treatment gives us back part of our life, it can be especially maddening when new doctors express doubt in diagnoses we have already received. Who would think patients would need to stand trial or be in need of a double-jeopardy clause? After years as a patient at a heart center, a new doctor declared "he doubted very much" I had heart failure without lifting his stethoscope or running a test. Apparently, he could tell by looking at me.

> **"Be assertive. Ask doctors what their grounds are for dismissing the conclusions of other medical professionals, rather than being lured into a defensive stance about your own credibility."**
> -Lucky Starzinsky

As a result of being in the dark about medical findings I had paid for, there were times people assessed my inability to perform my job as "non-compliance." Character flaws were assigned to what was in fact, symptoms. The slipshod handling of my care not only caused bodily damage and greater morbidity, but it also had serious consequences for my professional and personal life.

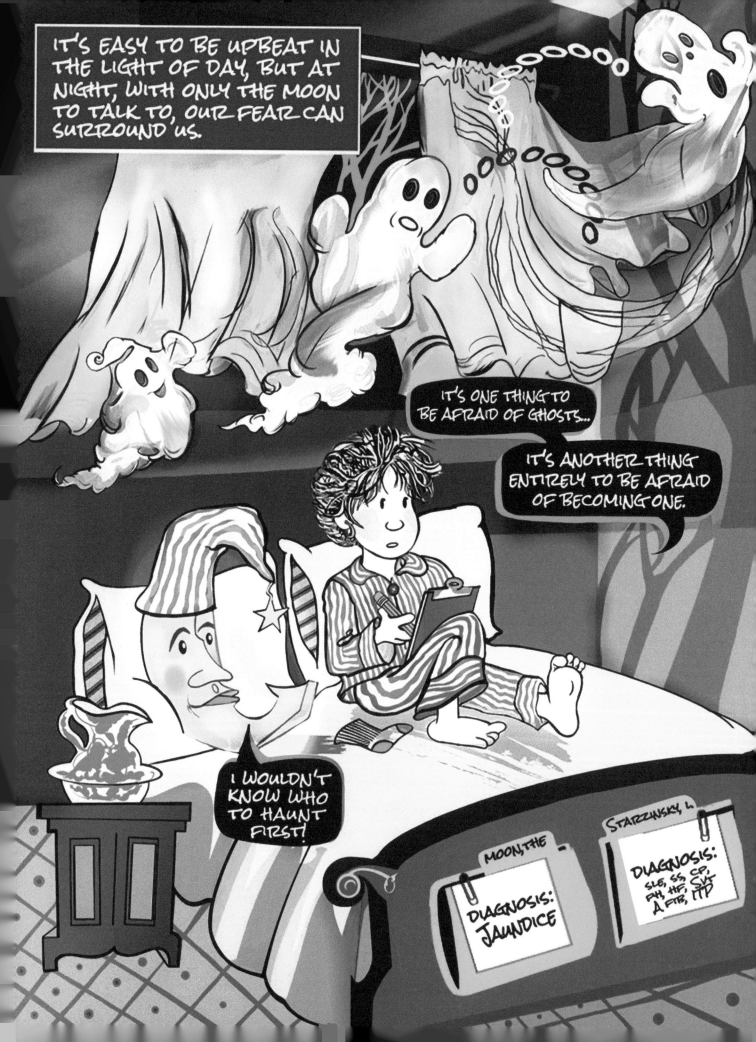

Only sixty percent of people whose immune system destroys their blood platelets show a positive on the antibody test. Many patients I spoke with at a blood disorder conference might have discovered their malady sooner if they had been told that their blood work had been showing low platelets for years. Sometimes doctors assumed it was simply normal for them, in spite of their patients' complaints about fatigue. We rely on doctors whom we pay for their evaluation.

Stories about other diseases follow a similar pattern. Some doctors make a judgment call to not burden patients with every abnormality. A "minor" problem can explain a symptom that could save many steps of exploration on the patient's part. And knowledge can help a patient prevent a minor problem from evolving into a serious one. I don't think there is a conspiracy to keep secrets from patients. It is a mindset, driven by such factors as triaging, not wanting to cause alarm, oversight, and many other things that are pure conjecture.

People don't persist in their search for answers just to irritate or undermine the doctors who have told them "all is well." They are propelled instead by the degree to which their life has been disrupted.

CREATIVE SPARK #8: "PUZZLE PEACE"

Buy a used children's puzzle that represents your "happy place." On the backside of each piece, write a question you have about your health, and the name of a person, book, or organization who might help you find answers.

Put the puzzle pieces in a big envelope and secure it to your fridge with a magnet. Periodically draw a puzzle piece and contact the resource on the back. Each time you get an answer, lay down the piece on a table until the puzzle is as fully assembled as possible. If the doctor you are seeing can't answer your questions, ask them to suggest what specialty to see. Hopefully, you will be able to see your life being put back together.

Impairments that create major disruptions to life *are* a serious problem for the patient, regardless of the cause. Whether the root of our symptoms is a minor culprit or a morbid illness, the impact on each life *matters*. Many able-bodied people decide that impact isn't an issue if a doctor is unable to attribute our pain to a specific ailment. The quest to resume activities that make our life meaningful and purposeful *isn't* crazy. With or without a green light from anyone else, don't give up.

Being able to maintain activities that make life *valuable* is as crucial as maintaining the functions that make life *viable*.

Don't treat a doctor's lack of concern as the end of the line if *you* still have concerns. There are intuitions about subtle changes that cannot be explained or dismissed. Pediatric emergency room workers will tell you that mothers are often the first to know when something is askew with their children's condition. A patient I interviewed felt uneasy about a sarcoidosis diagnosis he received. Though his grown children were angry that their father was "borrowing trouble," he chose to undergo an elective exploratory procedure. It revealed that he actually had stage 4 lung cancer. After treating it aggressively, he came back swinging, glad to have saved his life.

Other times we are blessedly wrong that something serious is going on. A patient with a benign brain tumor wanted it removed, convinced it was the source of his profound fatigue. The brain surgeon instead referred him to a neurologist. It turned out he had sleep apnea. The patient got his life back without an invasive procedure. In both cases, the patients simply knew they needed to feel better.

While there may be *some* discomfort we might simply need to learn to accept and live with, it is important that you feel you were thorough and asked the questions you needed to ask. Just be sure that people-pleasing doesn't come into play when it comes to your quality of life. Your puzzle is worth solving.

"Sometimes the smallest step in the right direction ends up being the biggest step of your life. Tiptoe if you must, but take a step."
-Naeem Callaway

My friend Ella Quint is the stereotypical poet. If a unicorn trotted down a rainbow into your room while you were reading her Facebook page, you wouldn't bother to look up from your phone because the energy from her page makes you feel *that* good. Ella has also been a fierce advocate, putting me in touch with a support group for pulmonary hypertension. The information I received from the facilitator, Val Yent, radically expanded my life chances.

Before putting me in touch with Val, Ella asked me if it was possible I was catastrophizing. I didn't realize at first that Ella asked the question because she took me seriously. I didn't realize that every time I casually tossed out a worst-case scenario, Ella went so far down the rabbit hole with me she could picture me in an ornate vase or pine box. She referred to the experience as doing "mental hopscotch." Now I am more mindful of how I communicate before I send Ella skipping through a new configuration of concerns.

Ella's question sent me down my own dark rabbit hole. Because she has earned my trust and respect, I sat with my uncomfortable reaction for a while before responding. My regard for Ella prompted introspection that generated the greatest leap in my self-love as a disabled person to date and ultimately deepened my appreciation for our friendship.

If someone you cherish says something that holds an emotional charge, consider the possibility that it is an innocent who has stepped on a landmine. It's too easy to hear everything through the filter of minimization that runs through our culture like a faultline. Most of us are sometimes hard on ourselves, wondering if we actually *are* making too big a deal out of our problems.

How we handle our situation impacts the people we love. They deserve to feel safe expressing how they are affected by without us becoming defensive.

It never hurts to take an inventory of where you are at and evaluate *what is true for you*. Was I treating my situation as more catastrophic than it was? After thinking about it, my answer was "yes" *and* "no." I ultimately decided that the *overall* changes to my career, family, finances, and wellbeing *were* catastrophic. On the other hand, I too often went straight to the worst-case scenarios when *individual* complications arose.

Taking an inventory deepened my respect for the havoc this disease had wreaked on my life. At the same time, it was with humility and gratitude I realized that every time a new organ was being damaged by my disease, Ella Quint ushered me all the way down the aisle. She cared enough to play mental hopscotch each and every time, and I needed to be more mindful about how I sounded the alarm when a new development arose.

"Between stimulus and response, there is a space. In that space lies our freedom and our power to choose our response. In our response lies our growth and our freedom."
-Victor E. Frankl

Self-awareness has a ripple effect. The greater respect *we* have for the impact our condition has on everyone's lives, the less we will project on people who actually do worry about us. How seriously do *you* take your situation? No matter what the labs say, no matter how your doctors categorize it, you can measure the impact of your health journey with numbers of your own.

The tally in the next Creative Spark solidified my self-respect as a Chronic Health Hero. The value of taking an inventory is not to wallow, but to operate from a clear understanding that eliminates denial and shame. These numbers count! Your blood work *might* be improving, but your other numbers in this activity show your investigation isn't over. You might even bring these numbers to your doctor visits to show him or her a more measurable shift in your quality of life. They hear the same adjectives all day. Quantifying your experience will likely be appreciated.

CREATIVE SPARK #9: "RUNNING YOUR NUMBERS"

I have underlined numbers in the next passage to give you some examples. Write down changes in your life in terms of measurable differences and losses.

I have been unable to work at a traditional job for over <u>10</u> years.

I haven't been able to take Alma on a vacation since she was <u>5</u> years old.

I went from being a co-sponsor of <u>2</u> of Alma's school clubs to only visiting her classroom <u>2-4</u> times a year for parent-teacher conferences.

I went to school for <u>8</u> years after high school to have the job I lost.

I was chosen out of over <u>300</u> candidates at that job.

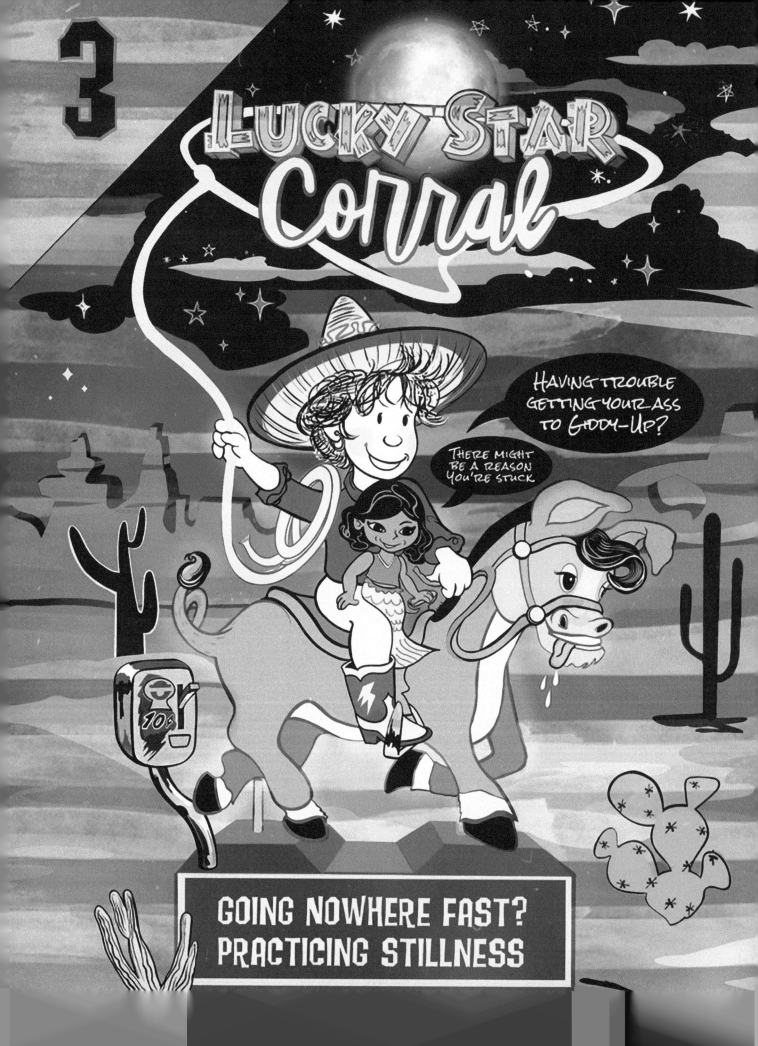

Chapter Three: Lucky Star Corral
Going Nowhere Fast? Practicing Stillness

"Actively loving yourself when you can't move is still progress. It might be the most important action you can take."
-Lucky Starzinsky

A bully throwing someone's inhaler down the school corridor might prompt onlookers to intervene more readily than an insurance company's denial of a life-saving drug. Although both situations involve withholding relief, the latter is carried out in a manner we consider "professional." Both examples probably end up with someone losing their lunch money.

In her book, *Civilized Oppression and Moral Relations*, Jean Harvey points out that "civilized persecution" is harder to combat than violent oppression, because it is procedural and hidden in plain sight. Adhering to a policy *sounds* like it's on the up and up, but adherence can be lethal.

Lucky Starzinsky learned about the difference between being ethical and being "professional" on the job. When a friend told her a bunch of clowns ran the Jingleheimer-Schmidt School District, she thought it was a metaphor. When she needed to go on medical leave, going through the proper channels proved to be a circus, indeed.

Lucky didn't anticipate any problems when she met with Principal, Bea N. Bonnet, and the boss's puppet, Marion Nett, to share what her doctor had advised. In fact, when Lucky heard an announcement asking her to report to the office shortly after her disclosure, she figured they had a Get Well Soon card or a box of chocolates up their sleeve. Instead, they handed her a "pink slip" and said that she was fired!

Lucky made an appointment with the head of human resources to straighten things out. Miss Construe saw Lucky's application for medical leave as a clever plot to turn her life into one big snow day. Lucky thought Miss Construe may have overestimated the quality of daytime television and the enjoyment derived from reading outdated magazines in waiting rooms. Miss Construe actually believed Lucky would be laughing all the way to the bank with her short term disability insurance money. Had Miss Construe divided sixty percent of a teacher's salary by expenses for a family of four?

Miss Construe most definitely had underestimated Lucky's commitment to her family. Letting them down would *break* the bank *and* her heart. She was the only breadwinner in the house at the time, and her family had just been told Alma would need dozens of surgeries.

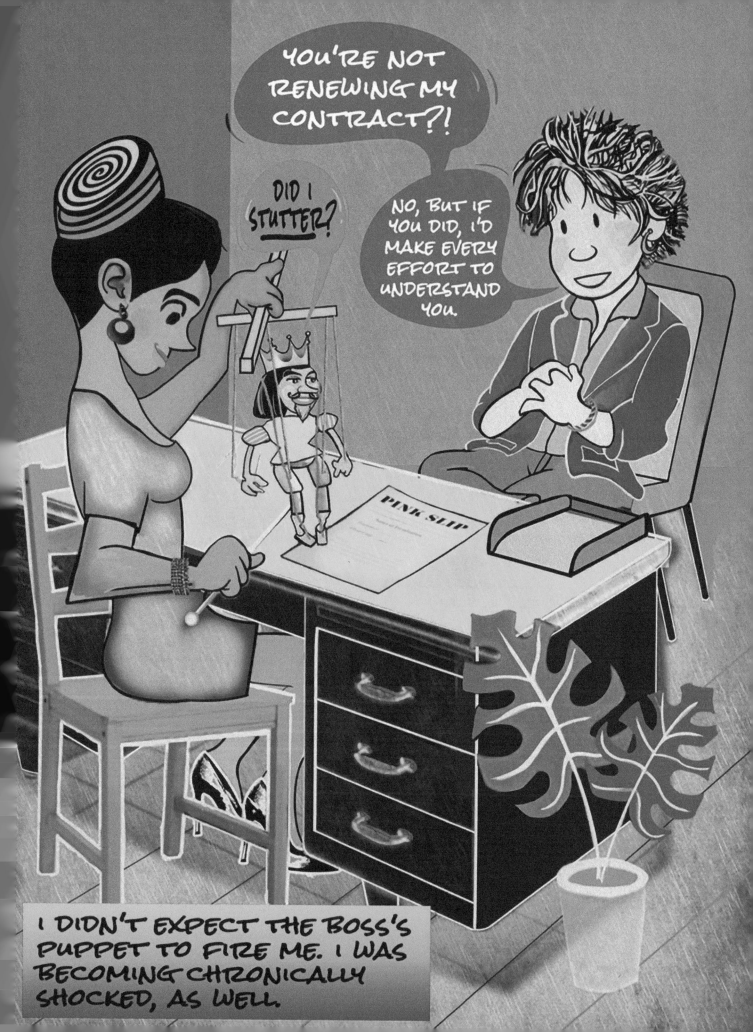

When Miss Construe told Lucky they would refrain from firing her if she voluntarily resigned, Lucky asked Miss Construe if there was a person whom she could speak to about the school's enforcement of the A.D.A. (Americans with Disabilities Act.) Fortunately, there was a district liaison for A.D.A. concerns. Unfortunately, that position was held by Miss Construe.

Lucky had Christmas-shopped for the kids like she was Daddy Warbucks in *Annie,* and they needed that January paycheck unless they all planned to live in a house made out of the Lincoln logs she had bought for Cory. Lucky spent the entire Christmas Break exchanging letters with Miss Construe, trying to save her job.

Lucky labored over the volley of emails like she was penning the Constitution until a light went on. Why was she vying for respect from an authority figure she no longer respected? Though her job still mattered, Miss Construe's opinion no longer did. Lucky shifted gears and began penning drawings to poke fun at the madness and the magic that is "cartoon therapy" was born!

"Decisions that have severe repercussions can fly under the radar because they are delivered by people wearing business casual, who speak in hushed tones."
-Lucky Starzinsky

Since that incident, I have noticed that when people are falsely accused, it's not just maddening because it's inaccurate. Often, people are mischaracterized as the <u>opposite</u> of who they are. It's one of the most crazy-making patterns in life.

Untrue accusations are often more of a reflection on the accuser than the accused. In Lucky Starzinsky's case, she had always been an honest, hard-working individual. When her illness thwarted her ability to perform, she was treated as unethical and lazy. Lucky would later discover, in the never-ending soap opera known as the Jingleheimer-Schmidt School District, that Miss Construe was projecting her own tendencies onto Lucky.

Sadly, being vulnerable can make us targets to individuals like Miss Construe. Even with documentation from medical doctors, Lucky was first denied accommodations and later treated punitively when she went on leave. It's even harder for those without a diagnosis. Because of all of the mindsets we have discussed, we can easily end up in hostile territory on the job.

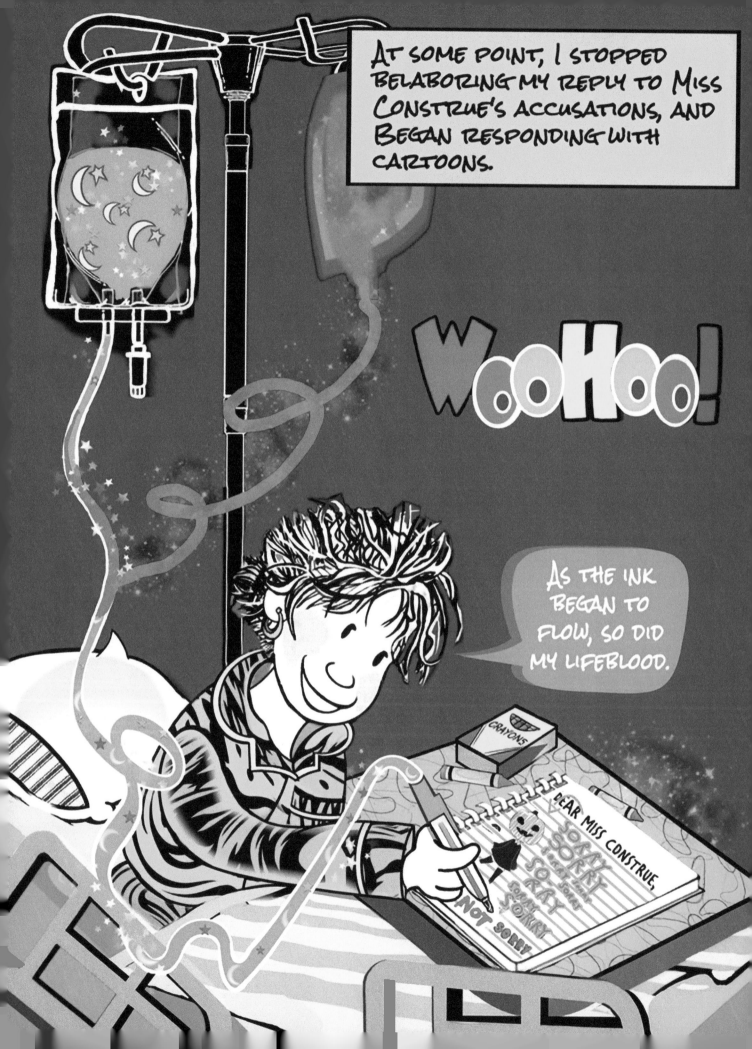

If adults go through tough times at work, issues play out for young people at school. A student with I.T.P. (Immune Thrombocytopenia Purpura), a disorder that causes blood platelets to be destroyed, had a note excusing him from participating in gym class. His platelets were dangerously low. His gym teacher openly ridiculed him. He insisted that the boy run laps anyway while being exaggeratingly accommodating to students who were visibly disabled.

"People assume you aren't sick unless they see the sickness on your skin like scars forming a map of all the ways you're hurting.
-Emm Roy, *The First Step*

It is hard to believe that any educated person would behave as if all illnesses were visible to the naked eye. If that were the case, radiological studies and blood work would be unnecessary to detect medical problems. Amazingly, people feel entitled to interrogate a person if their physical or mental illness is invisible.

CREATIVE SPARK #10: "TAKEN FOR A RIDE"

Write or draw a situation in which "civilized" or polite people compromised your sense of dignity. Portray the absurdity of the exchange by staging the event in a more whimsical venue, such as a carnival or circus.

In talking with dozens of Chronic Health Heroes, the number one complaint was that their problems were minimized because of Hollywood-like stereotypes of what a chronically ill or injured person should look like. I met the student with the discriminating gym teacher at a conference for people with I.T.P. (Immune Thrombocytopenia Purpura). He wasn't the only one who looked "normal." To anyone casting a glance in the hotel ballroom where we convened, we could have as easily been a 4H convention or people brought together by our love of gardening.

The invisibility of serious disorders can be striking. Gail Lantly was the youngest panelist to speak at the I.T.P. patient conference. If you saw her addressing the crowd, you might think she was a student council candidate or a prom queen contender. However, Gail missed her prom and many milestones that teens typically enjoy.

You would never know by watching Gail that she was engaged in a fierce battle for her literal lifeblood. A patient with 50,000 blood platelets is considered at risk for internal bleeding. Below 10,000 a person might require a transfusion. Even as Gail stood at the podium being a voice for so many others, her platelet level was at a stunning 7,000.

For some people with I.T.P., transfusions are not always an option because the introduction of more blood can signal the immune system to attack the platelets more voraciously. Many like Gail have learned to manage their disease at home when no more can be done in a hospital setting.

People tend to assume everything is fine when a Chronic Health Hero is discharged from the hospital, when it may only mean the person has no more treatment options.

Gail has done her part to dispel some of the myths by starting her own YouTube channel. When I see Gail Lantly streaming live, I can't help but stand a little taller. Sometimes there *are* more treatment options available, but they haven't been integrated into practice yet.

In spite of progressive leaps in treating I.T.P., many patients at the conference had been treated with steroids alone by their practitioners until they took the initiative to request the latest standard practices. There was unnecessary damage to patients' careers and undue stress on their families due to doctors who weren't current in their field. The outdated steroid-centered treatment subjected patients to more unchecked symptoms, as well as the side effect of emotional instability.

CREATIVE SPARK #11: "DEEP DOWN"

What if an x-ray could show the places you carried invisible strain, pain, or weakness? Draw a map of your body that shows the areas of distress, whether in body, mind, or spirit. The Aboriginal people from Australia drew people with a skeletal feel that represented the spirit of the being. Begin with a stick figure "skeleton," and pencil in your body around it. Use colors or symbols to delineate your battle.

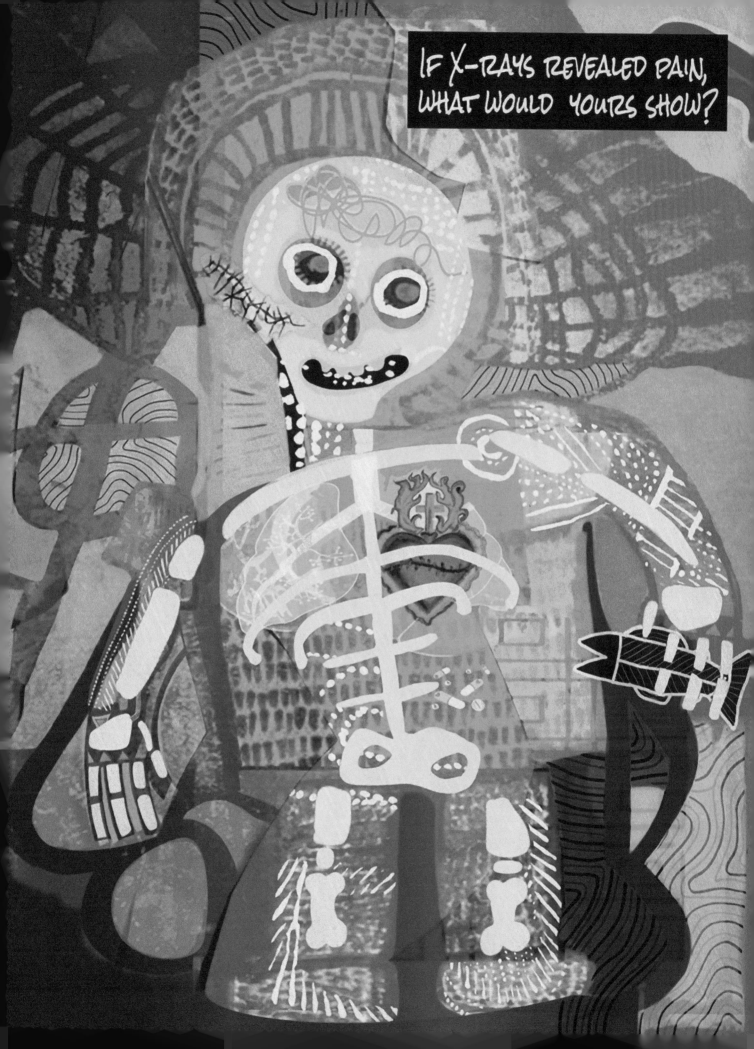

Chapter Four: Planet Lucky
Rocked World View? Keeping the Faith

"Wisdom comes by disillusionment."
-George Santayana

When some of us remember the "America" of our childhood, we think of the institutions that dotted the landscape; the libraries and schools, banks and hospitals, churches and stores. Not that long ago, interactions that arose from civic life provided opportunities for warm exchanges. Services were provided by someone we knew, or at the very least, people who were personable. We knew the name of the person who owned the gas station down the street and had the same insurance agent for decades.

The community interactions that once enveloped us in a network of support, now entangle us in an endless web of frustrations.

Those same exchanges that were an occasion for connection have been replaced by an automated, impersonal series of brick walls. The institutions and people we imagined might be there for us in our time of need often create additional obstacles to the relief we seek. Our sense of security takes a hit when our experiences don't line up with the safety net we thought we had.

One person whose sense of safety was shattered was Michelle "Shell" Schokt. Employed as a nurse in the office of a hand surgeon, she never imagined needing the services of her own medical office. When the pain in Shell's hands from rheumatoid arthritis prevented her from performing her duties, she lost her insurance along with her job.

CREATIVE SPARK #12: "BATTLE STATIONS"

Military historians typically map out individual battles of the war. Some battles are so famous that people have identities that revolve around those turning points. In the movie, *Stand by Me*, character Teddy Duchamp defends his father's honor simply by repeatedly referring to a pivotal battle in World War II, "My father stormed the beach at Normandy!"

On a piece of scrap paper, jot down the stand-out times in your health journey. From that list, create a map of key battles you have engaged in during your fight, be they victories or defeats. Symbolize these milestones with literal "landmarks" such as mountain peaks or rivers. Like soldiers who receive medals for the specific battles they engaged in, literally mapping out the rockiest terrain in your health journey can help you appreciate just how strong you have been.

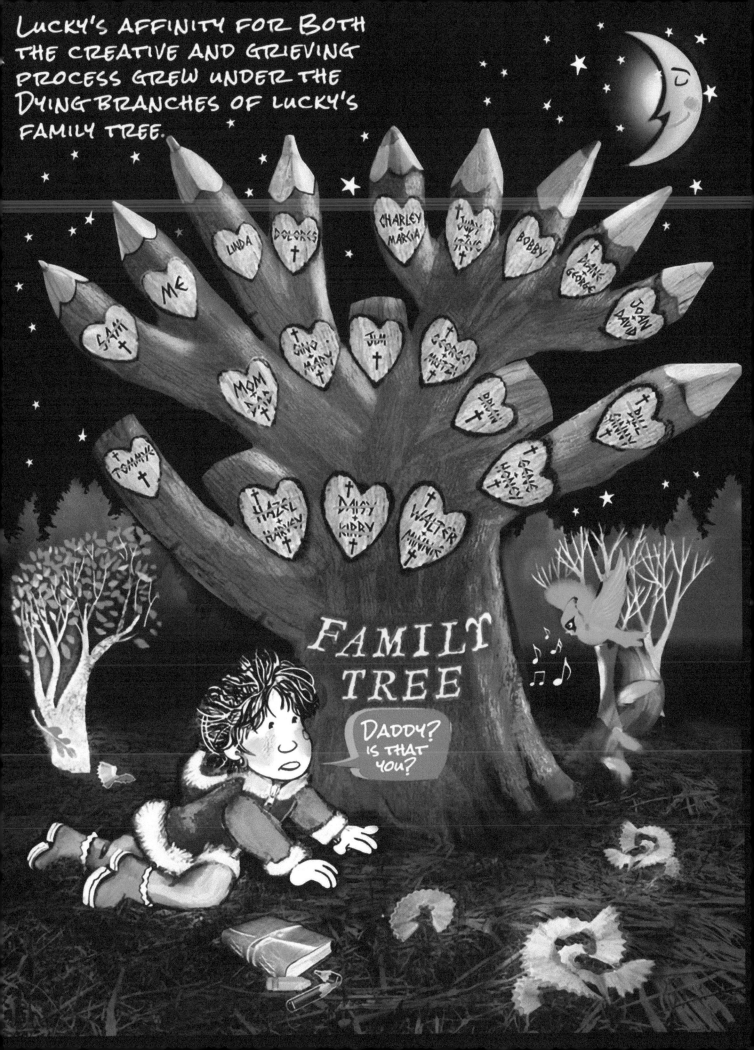

Shell Schokt had worked with Dr. D. Klein's for nearly twenty years. She thought of the people in her office building as a family. When Shell approached him about doing surgery on a payment plan, Dr. D. Klein declined. Encountering that kind of disconnection can be like looking into an abyss. And it is a darkness that can encroach upon your entire mental landscape if you don't actively search for glimmers of light.

One day grappling with my own world of disappointment on a walk, I wondered what kind of wisdom I would depart if something happened to me. I dejectedly thought my message would be that we could all do a much better job of how we treated one another.

Just then, I passed my local dry cleaner, run by Lee Way and his family. Our tiny dryer could not accommodate our bedding and Lee Way consistently gave me generous discounts when I brought in our blankets. I feel uplifted anytime I walked past his business or when I remembered my former landlord, Grace Period who always worked with me when the rent was due. She has since moved back home to England, but I can still feel her warmth from across the ocean. I take heart from all those who have shown us kindness along the way.

"Is the kindness we count on hidden in everyone?"
-Diana Krall

Today if I left a piece of advice behind, it would be to ask the question, "What's it like for you?" and then to *really listen to the answer*. I believe our relationships are too often put to the test because of our failure to listen to one another. Also, look and listen for the kindness that *is* there.

When you feel the sting of the world's cold shoulder, look for warmth in everyday exchanges. While it doesn't change momentous events that shake us to the core, your saving grace may be found in small acts of kindness. Interactions with good-hearted cashiers, phlebotomists, and pharmacists can be a balm to your soul.

We each have the power to nurture each other with "daily bread" if only we look for opportunities in these exchanges.

One day, a light on a larger scale came from unexpected quarters just when we needed it the most. In spite of everything, I had managed to keep a decent credit score. I thought if we could just hang on, homeownership could be our ticket out in a year or two. However, Alma was growing fast and her wheelchair was quickly becoming too large for our affordable basement apartment. I did not see a short term solution and I feared Alma would think I did not care about providing her with all of the accommodations she needed and deserved. I worried about finding a way to move from the time I got up in the morning until the time I tried to fall asleep.

Around that time, Alma's stepmom, Olive Branch, called and said she wanted to talk to me. When we met, I was stunned. She offered to help me bridge the gap in rent so that I could provide Alma with a more suitable home. Olive then took it a step further and purchased a home for me to rent, so that wheelchair accommodations for Alma could be added to the property without issue, including a sturdy ramp.

It was not only one of the nicest things anyone has ever done for me; it was one of the nicest things I've seen someone do, period.

Something deep within me began to heal that day. I had often felt judged after I got sick. Olive Branch's kindness gave me a peace I hadn't felt in nearly a decade. She gave me back my dignity when she owed me nothing. This situation taught me that it only takes one person's action to heal our hearts from the pain we have carried for years.

Above all, Olive Branch modeled to our daughter a willingness to accept and work with a person's limitations. Not only is it a beautiful circle of cooperation for Alma to grow up in, but it also gave me a priceless opportunity to co-parent from a far more grounded place, and be a role model that Alma could look up to. Every day that I am able to be more present to nurture Alma is a gift from Olive Branch and my co-parent, Gerry.

I'm glad that Gerry Riggs and I share custody of Alma because of the way our parenting strengths complement each other. Gerry has a talent for structure, whether constructing an elaborate calendar of appointments and activities or innovating ways to recalibrate medical equipment with what is on hand. I'm grateful that Alma has the benefit of all of our gifts.

CREATIVE SPARK #13: "OUR EVER-CHANGING UNIVERSE"

The changes brought about by a chronic condition can shake our faith in other people, in ourselves, and even in our actual beliefs. Draw the constellation of the changes in *your* world that affected your faith in life. Feel free to include any points of light you can find in the middle of all the clusters. Look at astronomy maps for inspiration if you wish.

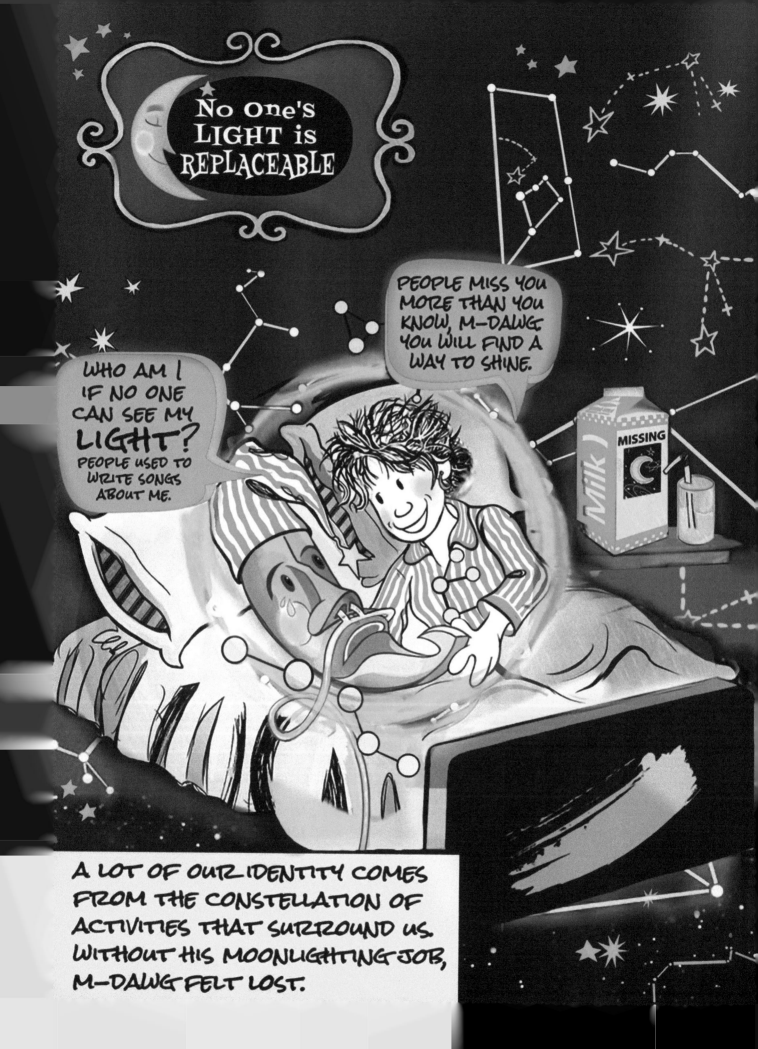

Even if we manage to keep our faith in ourselves and other people intact, our faith *itself* can be shaken by an illness. If we once believed that enough faith would move mountains, do we now feel like failures when our condition drags on year after year?

I concede that visualization, whether used as a tool in sports psychology, or in combating disease as recommended in the late Bernie Siegel's book, *Love, Medicine, and Miracles*, can be beneficial. *Yet,* when these helpful techniques are treated as absolutes, they can turn into hurtful yardsticks. True compassion places empathizing *with* suffering over theorizing *about* suffering.

Even belief systems as innocuous and basic as "staying positive" can inadvertently blame the person afflicted with a condition if taken too far. Wellness and other privileges, such as class and race, can compound how painful this over-simplification is.

In spite of living during a time when our communication has become more instant, sophisticated, and self-aware, it is not necessarily easier for people today to talk about difficulties. We live in an era when it is fashionable to demonstrate our good attitudes. People post pictures of their smoothies, map their circuitous bicycle routes, and flex their "spiritual muscles" in a show of positivity.

The pressure to curb authentic expression, in favor of demonstrating psychological prowess, is at an all-time high. Minimizing hardship isn't the same thing as having a positive attitude. Censoring our real discouragement only thwarts the very grieving process that would restore us to genuine wholeness. It is the unhindered plummet of the rollercoaster careening down that gives it the momentum to go back up. We can't regain real hope if we can't acknowledge our despair. Heartfelt optimism will never arise from hiding our pain. The mythical bird, Phoenix, rises from ashes, not cotton candy.

"I do have positive feelings. I'm positive I want to scream right now."
-Lucky Starzinsky

Everyone is entitled to draw conclusions about their *own* journey, but don't presume why someone else suffers. It's damaging. From conservative religious organizations to liberal new age spiritual centers, there are theological schools of thought that inadvertently blame the victim by viewing afflictions as a sign of sin, "dis-ease," or lack of creative visualization.

The attitude permeates our culture. Although neither Gerry nor I raised her with this ideology, when Alma learned she would need to undergo a nineteenth surgery, she tearfully wondered out loud, if the universe hated her? When our lives inflict so much pain, it's a natural reaction, but where does the concept of mercy fit in the recommended culture of positivity?

In the New Testament, Jesus instructed his followers not to assume a blind person or his parents

had sinned to cause his sight loss. The Mahayana Buddhists believe that there are some souls called Bodhisattvas who have achieved Nirvana but elect to continue to reincarnate to help other souls, often choosing a path fraught with difficulty in the interest of becoming a healer.

There are many alternative ways to view suffering, and it is up to each of us to interpret our own meaning out of suffering in our own walk of faith. There are hundreds of Native American tribes with distinct belief systems. *Wakan Tanka* in Lakota is interpreted by Europeans monotheistically as "The Great Spirit" but a more accurate translation is "The Great Mystery." Why suffering exists is a question I relegated to the same Great Mystery who made the galaxies and oceans.

After her near-death experience, Anita Moorjani said, "I can't say this strongly enough, but *our feelings about ourselves* are actually the most important barometer for determining the condition of our lives! In other words, being true to ourselves is more important than just trying to stay positive!"

CREATIVE SPARK #14: " FANTASYLAND"

Sometimes things are far from where you want them to be. So that you can laugh *while* you cry, draw or write a scene of how things would look if they were going ridiculously well. In other words, take a magic wand to an aspect of your life.

"I allow myself to feel negative about things that upset me because it's much better to experience real emotions than bottle them up. Once again, it's about *allowing* what I'm actually feeling, rather than fighting against it."

-Anita Moorjani, *Dying to Be Me*

We might also look to human nature rather than the divine to explore the question of why suffering exists. After all, it isn't God who curls his finger around the trigger of a gun, slides behind the steering wheel after three drinks, or dumps toxic waste into the soil. Whatever our personal beliefs are about the divine or human cause of our *own* suffering, we should tread lightly when it comes to conjecture about someone else's plight. If you have ever walked the corridors of a children's cancer ward and stayed up all night with parents who sold their house and earthly possessions to save their first-grader, it is impossible to blindly attribute cause and effect to a matter of faith. The hospitals are packed with as many good, faith-filled people as the churches. Who are we to judge (especially ourselves?)

"Just because you are struggling doesn't mean you are failing."

-marcandangel

Believe it or not, feeling sadness can actually be a sign of strength. Our psyches were brilliantly designed. Our minds won't allow us to grieve unless we have enough inner support. Our mind will obscure the writing on the wall until it knows we have the internal resources to read what it says. My friend Heartha called this kind of surrender to emotions a "nervous breakthrough."

If we allow emotional collapse, it is because on some level we know there is solid ground beneath us.

When I was a chaplain, I had to resist the urge to hide all the Bibles because they were packed with stories about miracles--in a hospital full of good people who were often not experiencing them. Being a chaplain gave me no easy answers. It only deepened my appreciation for the *grandness* of the mystery and the important role we each play in embodying God's mercy on earth. Although I have seen a couple of flat-out miracles, I saw many small miracles brought about by people who allowed themselves to be used as an instrument of peace.

Every world religion invites the believer to be a light. It is when we are without the holy "communion" with others that our world grows dark. When wellness is used as a measure of a spiritual superiority, it creates division. Let go of proving yourself and create more room to love yourself. When a medical situation doesn't ease up or disappear, you don't have to accept the subtle and overt messages that suggest a lack in you as the cause.

"If you find someone is using spirituality as a yardstick, grab it from them and throw it in the trash."
-Lucky Starzinsky

Although it was controversial, I think Mother Teresa did a great service to humanity by admitting in her autobiography that she wrestled with her faith. Continuing to seek the source of life when there are no outward signs in sight, might be the greatest faith there is.

Sometimes a more mature faith emerges when we realize that we are not involved in a simplistic system of reward and punishment. The *Chinese Book of Change* says that in order to have a sound character, we must accept that there is evil in the world. It is also important to know that sometimes what seems to be evil or a monstrous indifference is actually the space in which one person's trauma collides with another.

My cousin Houston understands that faith doesn't mean denying the uphill battle, "The last year has been the hardest of my life. So many ups and downs. So much crying and sadness, but when the truth is known, I am still alive, and that's a miracle in itself. Yes, I get depressed and wonder 'why me?'"

WRESTLING ☆ WITH OUR ☆ FAITH

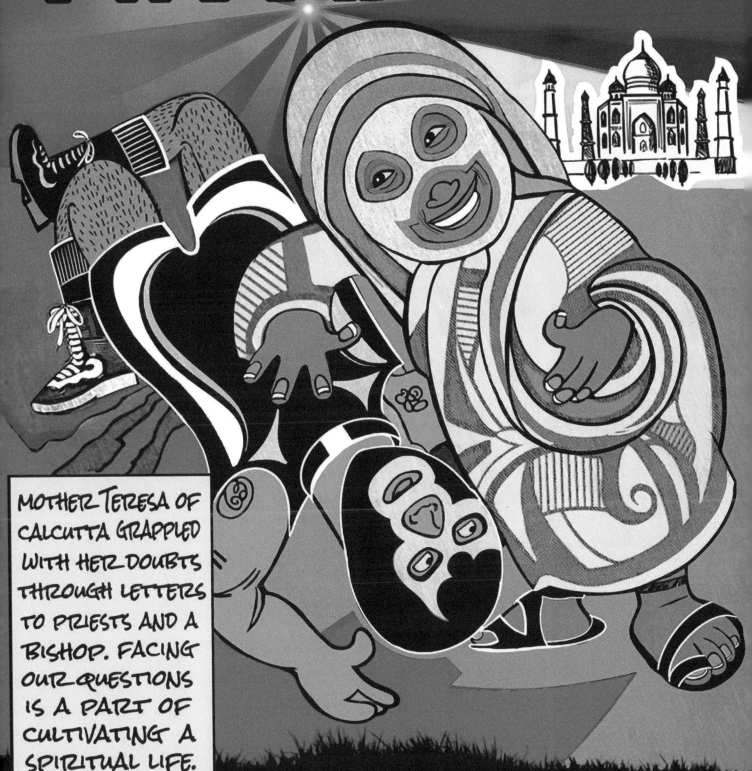

MOTHER TERESA OF CALCUTTA GRAPPLED WITH HER DOUBTS THROUGH LETTERS TO PRIESTS AND A BISHOP. FACING OUR QUESTIONS IS A PART OF CULTIVATING A SPIRITUAL LIFE.

"As we acquire more knowledge, things do not become more comprehensible, but more mysterious."
- Will Durant

One of the conversations that moved me the most as a chaplain was with a parent immersed in life's questions. His paternal love made him a hostage, forced to witness his son, Brendan, go through an ordeal that would have brought anybody to their knees. The change in Brendan was distressing. His face was swollen beyond recognition, he looked nothing like the little boy who was admitted at the beginning of his journey. I was struck that his family prayed with the same degree of fervor at Brendan's twenty-first surgery as they did at the first.

The image of this father sitting alone in his son's hospital room during my last visit was forever etched into my mind.

He looked up from the Bible that was open on his lap to meet my gaze. With complete frankness and quiet anger, he said, "I have been sitting here, reading the book of Job, about this God that is supposedly loving and merciful, fatherly and compassionate. I have been waiting on *that* God, and I have yet to see Him."

To this day, I cannot remember this exchange without crying. I could only tell him that I was disappointed too and that I would never stop waiting with him. Many of us have been trying to live without being able to feel God through someone else's loving gaze or touch. We have bought into the lie that the love we need can only be administered by the well and the unbroken.

It has been almost a decade since I have seen Brendan's father, yet I can never see the name of the town where he is from without thinking of him. I wish I could tell him that I still pray for him, just in case God still hasn't shown up. It is what I believe God would want me to say if God indeed is love.

Chapter Five: Lucky in Love
Ruffled Domestic Bliss? Tending the Home Fires

"I feel there is nothing more artistic than loving people."
-Vincent Van Gogh

Understanding that your significant other, children, or pets have needs that you would still like to meet, but can't, is hard. There is still an essence that is uniquely yours to bring. *Bring it.* Focus your attention on the people you are with, rather than what you can't do. Come up with new traditions and roles for yourself.

You may not be able to hike with your husband, so invite him to share a cup of coffee. You may not be able to go to your stepson's parent-teacher conference, so write him a note expressing your pride. You might not be able to walk your dog, so invite her into your lap. A smile, a listening ear, and eye contact can do wonders, especially if you remember that you are beautiful and whole and lovable.

Some may think grieving over our own illness is self-centered compared to crying over the loss of a father or a dying aunt. It isn't. All mourning is tied to losing a connection. When we lament the loss of a relative, we miss what we *received* from that *one* particular person's presence.

Mourning our own connections to our family, altered through injury or illness, means the love we *extend to many* is now compromised. Whether through acts of service or earning power, our contribution radiates, like branches on a tree, to everyone we love. And now, our ability to be a channel is severed in many ways, in many directions.

Children sometimes have a better sense that their *very presence* is of value to the people around them. And that valuing of self is possibly the ultimate sign of concern for others. As a chaplain at a pediatric hospital, the most requested prayer from children with terminal illnesses was for God to help their parents cope with their sadness. They understood that they gave their family something irreplaceable through their presence. And sometimes the children I served asked God to please help their parents let them go so that they could finally surrender in peace.

I sometimes found the confines of illness as hard as losing twenty-three of my immediate and extended family members died early in life. When I was in the throes of mourning their collective loss, I couldn't stand to listen to the radio because so many songs reminded me of a *time in my life* when they were still here. When my health declined, I couldn't bear to watch television, because it hurt to see the portrayal of *life itself.* People on shows had careers, went on vacations with their children, enjoyed intimacy, went to work, and attended social functions.

When life gave me a second chance to have a family, I knew how precious it was. To not be able to be there for them to the extent that I wanted, especially when they were vulnerable, felt like torture.

CREATIVE SPARK #15: "BACK TO THE FUTURE"

Sometimes we don't just grieve what we had in the past, we mourn the things that may never come to pass: the anniversary trips we would not ever take, the retirement party in a future decade, the championship game we will never play. Draw future events you once anticipated but no longer think are possible or likely.

For almost a decade, I have had less participation in the aspects of life that could give it meaning. I also have no timetable to tell me if or when I would return to the people and activities that mattered. At the same time, my sense of gratitude for everything I could still do was heightened. Not many songs are written about the achievement of getting out of bed or slashing your grocery bill. Most music is written about love, particularly romantic love. Whether you were basking in domestic bliss or were turning up the heat on Tinder when your health worsened, the joys of intimacy can suffer. And the right pair of earrings or jeans just can't fix that.

There will always be those comrades who raise ten kids and never miss work and make the rest of us look bad. I was doing my internship as a chaplain when I was paged to the room of Roger Wilco in the ICU, but not to minister to him. Mr. Wilco was on the precipice of death but it was Mrs. Wilco who had me paged.

Mrs. Wilco simply wanted to recount what her husband had meant to her. Her eyes filled with tears of admiration as she proudly reported that her husband had been a pleasant person throughout their six decades together. She dug out an old photograph of Mr. Wilco when he served as a paratrooper in World War II. Apparently, he was a trooper in his fight for health as well! Mrs. Wilco took my hands into hers as she shared, "In the eighteen years my husband has been sick, Roger hasn't uttered a single complaint...not one single day."

I decided then and there if I ever got sick, I would follow in Roger Wilco's footsteps. The problem was, I am not good with numbers. For months, I made it a point to complain less than eighteen times on any given day!

"If opening your eyes, or getting out of bed, or holding a spoon, or combing your hair is the daunting Mount Everest you climb today, that is okay."
-Carmen Ambrosia

CREATIVE SPARK #16: "A BEAUTIFUL MESS"

Draw or write about yourself in a loving light being the <u>opposite</u> of a "good patient" or "a real catch" during a time frame when you were uncontrolled, agitated, scared, vocal, or emotional. Being able to lovingly make fun of yourself when you feel tattered is awesome.

If one has a significant other, there is nothing wrong with going to that person with our concerns. However, because chronic health battles set off so *many* bombs, occasionally sorting things out on our own first, with journaling, leaning on friends, support groups, and counseling can shore up our bond with our significant other. Having clarity about what our goals are in conversations will save us from the meandering that can be detrimental to the health of our relationships.

Allow yourself some form of counseling, free or paid, while you go through the rigors of ongoing recovery. Even the calmest among us are susceptible to becoming a loose cannon if we don't have a consistent outlet.

Sharing mindfully isn't to "*look* good" for others, rather it's to enable you to *feel* good about yourself and to be thoughtful toward your loved one. Keeping up appearances can't replace confidence. Investing a half-hour to journal is just as important as thirty minutes spent at the nail salon. Part of the reason schools do fire drills is that when we are in the throes of an upsetting event, it's harder to think. Chronic health battles set off a lot of internal alarms that also make it hard to think.

You need a plan to fireproof your relationships.

When you have a challenging doctor visit, or are met with an insensitive comment from your manager or sister, or you just plain don't feel well, make sure that some of your go-to moves include ways to self-soothe. You are already managing emotions about what is happening to you as well as how it makes you feel about yourself. Try not to confuse your family's disappointment with your *situation* with them being disappointed in *you*. When I got sick, Alma was only three. She told me she missed me giving her baths. It really touched my heart, and still does. It is important that our loved ones be able to express their own sadness and frustration, at any age.

Some couples' relationships cannot survive the fallout. Any pre-existing problems can be brought to a head with the additional pressure a chronic condition places on both parties. Some couples *can* and *do* survive. My cousin, Houston, and her husband Apollo have become a more unified front in the storm of disillusionment that families of the sick and injured often face.

CREATIVE SPARK #17: "SKITTISH"

We all have occasions to storm through the door fuming because of something someone said or did. If you don't want to make your family "skittish" around you, slow your roll, and do a comical skit! Making fun of a less-than-desirable response from a well-intentioned person can leave you feeling lighter. If Dr. Drew A. Blank didn't order tests *again*, re-enact the problem behavior with a comic flair. If you prefer, draw the interaction instead. If someone was downright mean, consider drawing them having a bad hair day.

If there are children in your family, weathering a change in the health arena can be especially poignant for them. Devoting time to your own care will ultimately aid your devotion to the people you care for. Set aside clearly defined time for both. The more firm you are about your limits, the more you can give love authentically. Although it is tricky to know you are "enough" while striving to adjust your reach, it is possible.

Sometimes kids may feel they aren't "enough" as well. They may inaccurately feel they have done something wrong to deserve less of your attention. Explain why you are doing less with them so they don't fill in the blanks in a hurtful way. Draw parallels with examples from your life. "Do you remember when you had your tonsils out, and you couldn't go on that field trip with your class? That's how I feel when I want to do things with you. I still love being with you just as much." Don't assume you know which changes are hard for them. They might be doing a secret happy dance that you don't want to play Yahtzee anymore because the way you shake the dice sounds like an earthquake to them.

Ask your loved ones what they miss the most, so when you do have energy, you can spend time in a way that is meaningful to them.

You can say to kids, "You can talk to me when you wish things were different. We can figure out what we might do instead." Although this situation was never one you wanted, your kids are learning priceless lessons about flexibility, authenticity, and love.

Chapter Six: Lucky Charms
Social Graces Sliding? Saving Face

"Oppression is a depression that comes from encountering bias."
-Alma Mater

Let's face it, no one expects someone with the flu to look or act their best. Actors who are on commercials for cough syrup reinforce this stereotype. They are made up to look like they have been crawling, combat-style, through an overgrown jungle. Rumpled pajamas, disheveled hair, and a face adorned with blotches and bags are almost endearing in a studio setting.

When someone with an autoimmune disorder encounters the same minor affliction, it is not so endearing and can trigger a flare-up of serious attacks on the body. Whether it is your platelets or your joints that are affected, you will need more than a couple of cough drops.

With many chronic injuries or illnesses, there are no outward signs of the chaos within. And because we have lived for so long with discomfort, loved ones may not attribute our questionable fashion choices to not feeling well. On the other end of the spectrum are Chronic Health Heroes who make a concerted effort to look well, which could also backfire. The person is perceived as not really *that* bad off because their Facebook selfies don't look half bad. I can usually strike a pretty decent pose by the five-hundredth selfie.

What people also forget is that conditions *fluctuate*. The same Wheelchair Basketball players that are killing it on the court today, might have been in the hospital for a procedure weeks before. It doesn't mean their surgery was a hoax. I have a friend with Lyme Disease who is an avid rock climber, and other days she is confined to bed.

When our day-to-day routine is disrupted for long stretches, the lack of regular contact can affect the quality of our interactions, hygiene, or self-esteem. We may also be less tuned in to social trends, slang, and have less to contribute conversationally.

This is especially true for those of us who can no longer work a regular job. The likelihood that anything interesting will happen while we steep our kombucha tea bag is not as high as a typical day at the office. Our stories about the drive to the loan shark and the pharmacy are hardly page-turners. I realized that my withdrawal from my former professional and social life often left me at a loss for words when I picked my daughter up from school. I had become...well, boring.

When less happens in our day, we may have less to *report*, which in turn affects our *rapport* with others.

Once I was aware of this, I tried to read interesting articles before I picked Alma up from school. Working "fifteen things you didn't know about hippopotamuses" into a conversation was about as graceful as maneuvering an actual hippopotamus into the van. A rehearsed conversation never meshes as seamlessly in real-time. One day, Alma was upset about an interaction at school. She was definitely *not* comforted to know that when *hippos* feel upset, their sweat turns red. Cars three spaces ahead of us could have seen her eyes roll had they glanced in their rearview mirrors.

When I hosted a pajama party at our house, I saw my chance to be "the cool mom," and interjected a seemingly relevant animal fact I had tucked away. Looking back, I can see that informing Alma and her friends that a polar bear can eat eighty-six penguins in one sitting was a bad idea, especially considering they were watching the movie, *Happy Feet,* about animated penguins.

CREATIVE SPARK #18: "PUPPET SHOW"

This might be the most powerful conflict resolution exercise in the book. Often we argue without knowing exactly what it is we seek! Sometimes we hear people say, "Don't put words in my mouth." But what would happen if we could? Make some puppets using socks or lunch bags with some markers to represent yourself and someone you had a less than ideal interaction with.

Re-enact your exchange, but this time, make the other person say *exactly* what you would have liked them to have said. It is an effective way to get to the heart of what you want in a conflict. Once you determine what you most wanted the other person to understand or affirm, you can enjoy a more fruitful dialogue. If you are feeling brave, invite them to do a similar puppet show of their own.

Chronic conditions can take a gradual toll on our demeanor, as we become progressively less considerate, patient, and demonstrative. I always envied the people who brought donuts to the office or fresh flowers to the dinner party. Usually, it was all I could do to get myself there in terms of energy and actual gasoline.

Part of our own loss of "charm" lies in the things we no longer give to others. Social graces aren't just about *looking* nice, it's about *being* nice, like the ability to provide babysitting for a friend or volunteer after church. The intangible loss of what we are able to give energetically can be just as distressing as the loss of earning power.

The Pursuit of Happyness, a movie based on the true story of Christopher Gardner, altered my ideas about what success looks like. Gardner was a homeless father who made it to Wall Street in New York City. He looked anything but heroic on the rocky path that led to success.

The night before his interview for an internship with a prestigious firm, Gardner was arrested for

unpaid parking tickets. Released from jail just forty-five minutes before his interview, the protagonist arrived in sweat-soaked, paint-splattered clothes. Gardner kept it together in the interview and landed the opportunity. He maintained his dignity in the face of his young son's disapproval as they frequented homeless shelters and all-night diners in between his demanding workdays.

"The person who is passing you in the race, without breaking a sweat, may not be stronger, smarter, or more dedicated. You can never tell by looking at someone, the distance they've already come."
-Lucky Starzinsky

The Pursuit of Happyness helped me embrace the rigors of my journey. There were times I heated up frozen meals instead of cooking and let Alma watch TV instead of reading to her. When I did take us to a nearby playground or to a classmate's birthday party, I often looked like I had spent the night in the subway. Instead of beating ourselves up, when we are disheveled, sweaty, or exhausted, it is helpful to remember we are giving our own Chronic Health Hero's journey everything we've got.

CREATIVE SPARK #19: "Blackout Poetry"
Get a used copy of a short book that means something to you. Select several pages, then use a dark marker to block out all but a few words. The words that remain form a poem of sorts.

When people are devastated by a shared disaster, such as a global pandemic or a damaging weather event, the affected group eventually adjusts to collective new normal, but when dealing with chronic illness as an individual, our condition can begin to color our optimism about hopes and dreams, in ways others can't understand. Tension with the lawyers, doctors, banks, bill collectors, loan sharks, judges, ex-employers, insurance companies, pharmaceutical companies, family, and friends takes a toll. Last but not least, there is the disease itself to contend with! By the time we reach out to friends and family members, any remnant of social decorum would be a miracle.

That's why it's critical to schedule a one-on-one time for emotional self-care, and if you can find a counselor or support group even better. Otherwise, when we manage to make it to the rare get-together, we might forget that no one wants to hear about our endocrinologist while they are lowering their potato chips into the French onion dip.

CHAPTER 1

Candy

In my memory's sketch of early childhood, drawn by an artist of the impressionist school, there is one image that stands out above the rest—which when called forth is preceded by the mouthwatering aroma of pancake syrup warming in a skillet and the crackling, bubbling sounds of the syrup transforming magically into homemade pull candy. Then *she* comes into view, the real, real pretty woman who stands at the stove, making this magic just for me.

Or at least, that's how it feels to a boy of three years old. There is another wonderful smell that accompanies her

Sometimes we will want more from people than they have to give, just as sometimes people want more from us than we can give.

It is when we are without the traits that drew people to us that we most need to mend fences with the able-bodied people who still seek us out. Even as we reject their sometimes imperfect attempts to embrace our imperfections, moderation on all sides is the name of the game. It is when withdrawal becomes the norm that our physical and emotional well-being can suffer. I have friends with Lyme Disease, ITP, and a host of other debilitating conditions. What we lack in physical stamina to help each other, we make up for in a shared understanding.

Of course, there are healthy people who understand and comprehend far more than we know. Although it is tempting to put a "closed" sign over your heart, something unexpected happens when you make the decision to be open to loving kindness from others. You begin to find it from the bank teller, from the person trying to lure you to their kiosk at the mall, even from bill collectors. I used to tell my art students that true success is keeping your heart intact.

"Maybe the most beautiful act in all the world… is to open our hearts even as they are broken. To nurture your tenderness even though it is easy to turn bitter. To remain gentle and supple although everything in you says go hard. To keep your soul open and facing the sky, even though you cannot yet see the light of the sun. "
- S.C. Lourie, Pebbles and Butterflies, Instagram

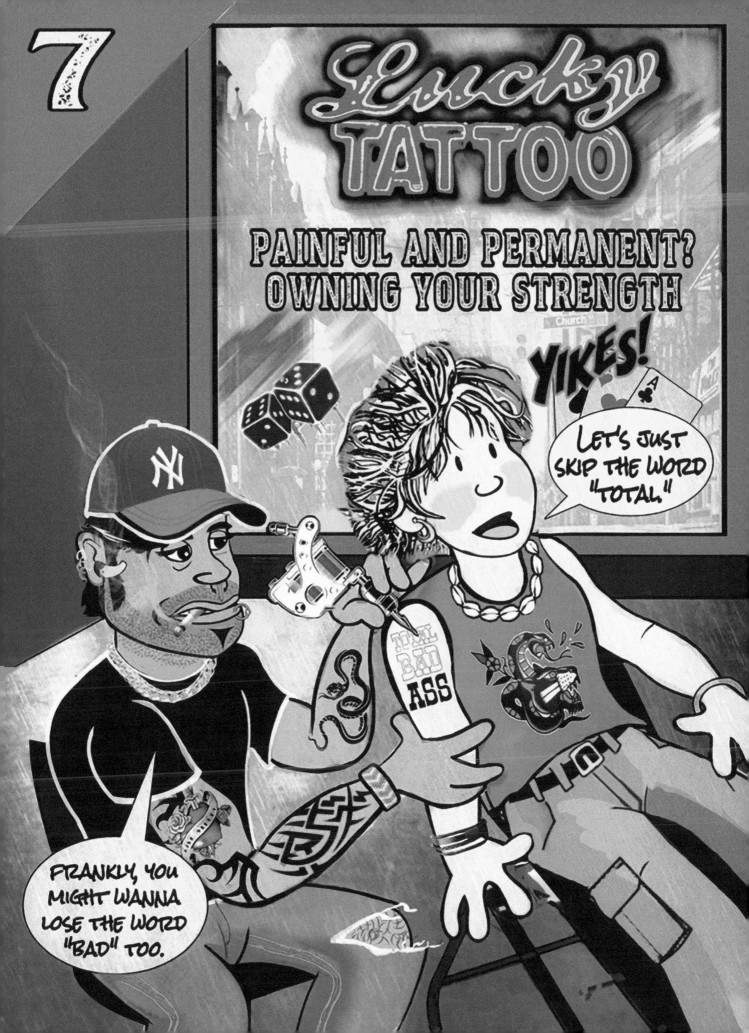

Chapter Seven: Lucky Tattoo
Painful and Permanent? Owning Your Strength

"Sometimes monsters are invisible, and sometimes demons attack you from the inside. Just because you can't see the claws and teeth does not mean they are not ripping through me. Pain does not need to be seen to be felt."
-Emm Roy, *The First Step*

If we simply lost the propriety that came from stirring our coffee with the wrong end of the spoon, it wouldn't be the end of the world. Even if we failed to use a spoon and slurped our alphabet soup straight from the bowl, we could probably still realistically hope to become President of the United States one day.

If we are honest, we have lost more than good manners. It is our spirit that is broken. And underneath that truth is the root cause: there is an organic malfunction inside our bodies. Whether those dysfunctions create pain or limit action or both, it takes us out of the game where we derive meaning.

Most people agree that even an hour of compromised internet service can negatively affect them. Unless people live in a city where public transportation is easily available, most Americans also can relate to the inconvenience of not having a car, even for a few days. But when it is our bodies that put us out of commission, some people are suddenly perplexed by what the big deal is. People even seem to understand survival itself more, in the context of a contract to be in danger on a reality TV show. In fact, I found myself feeling agitated when watching participants on the show, *Alone*, similar to its predecessor, *Survivor*. Seemingly healthy people subjected themselves to physical punishment on camera while braving the "elements" in order to win the $500,000 prize.

I was envious that these risk-taking reality show contestants were getting more respect and admiration for seventy-five _days_ of elective misery than I had ever gotten for ninety-six *months* of involuntary suffering.

I can tell Alma feels the same irritation when she sees grown-ass adults throwing themselves off of bridges, airplanes, and cliffs with only a bungee cord tied around their ankles. Having had such painstaking repair to her own bones via multiple surgeries, Alma is mystified to see people willingly hurl their skeletons from dizzying heights.

Our number one gamechanger doesn't involve a visible obstacle course or a cheering section. There isn't an option to be helicoptered off the island when the going gets too rough. There are medics standing by to tend to the self-inflicted conditions borne of competing on TV.

Our challenges aren't really allocated to a certain location or time slot. Our disease or disability doesn't have a face, but it might just help to give it one.

CREATIVE SPARK #20: "CHALLENGE PERSONIFIED"

Some people don't consider their disease an enemy. For some, their condition is a friend, a teacher, a beloved part of them. For others, it's a mixed bag. In this activity, you will personify your disability or illness as an animal or a person. I chose to portray my autoimmune problem as Otto M., a pirate who stages mutinies (my Otto M. Mutiny problem, hardee-har-har.)

"Maybe life isn't about avoiding the bruises. Maybe it's about collecting the scars to prove we showed up for it."
-Hannah Brencher

Systemic diseases, in particular, are often judged as hypochondriacal ideation ("it's all in your head" or "you are making it up") because of how wide-ranging the damage can be. Recent studies show there are certain diseases that regularly occur genetically in groups. Collectively, autoimmune diseases are a leading cause of death among young and middle-aged women. A recent study looked at the cause of death listed on death certificates and revealed that autoimmune diseases were the sixth or seventh most frequent underlying cause of death among females in *all* age groups below age seventy-five and one of the leading causes of deaths in the United States for women under age sixty-five.

The World Health Organization has reported that categorizing autoimmune diseases individually has obscured the morbidity of this pathology. Because of that underestimation, research on adequate intervention is not as well-funded as more common conditions, such as cancer. As a deeper understanding is unveiled, a corresponding societal response to chronic illness and injury will hopefully follow. Gender and race have also sadly played a role in the need for research.

People in medical battles can run out of emotional as well as physical steam. If you or someone you love has outwardly lost their vitality, able-bodied loved ones should explore whether Chronic Health Heroes might also be struggling to hold on to their will to stay engaged in life. "Fighting Spirit" is a phrase for a reason. In hindsight, I felt like I was dying right before people's eyes—because I was. If I had let my extreme fatigue and ill-informed comments halt my pursuit of a viable treatment, I would be far more debilitated—or not here on this earth at all.

It is also important to educate the public because chronic illness exponentially increases the risk of suicide in the patient.

Further complicating our search for relief is the time lapse between research being completed and making it into practitioners' hands. I came across a journal entry from that time period when my spirit and drive were fading fast:

Is there any substance soft enough?
Is any wisdom deep enough?
Is any faith enduring enough?
Is any deity merciful enough?
Is any shelter sturdy enough?
Is any touch tender enough?
Any medicine healing enough?
Is any balm soothing enough?
Is any food nourishing enough?
Any words comforting enough?
Any respect abiding enough?
To set me free?

CREATIVE SPARK #21: "CHAMP STAMP"

Think about the following questions as you design a hypothetical tattoo for yourself. Do you want to strengthen your grasp on the positive regard you have for yourself? What do you most want people to know about you? Are there any ideas that inspire you? Make a list of words and images you associate with your answers. Circle your favorite three or four and use a search engine to explore ways different cultures symbolize these concepts. Combine your favorite visuals to create a tattoo that expresses the strength you want to feel and convey.

You shouldn't have to defend your quest to survive. We aren't on a reality TV show. We are in it to win it for the best life and for life itself. An NFL team wouldn't be very formidable if they felt sheepish about their goal to defeat the Oakland Raiders or Dallas Cowboys. So don't apologize for being focused on holding your own on the court when it comes to your health. When sports teams watch tapes about the weaknesses of their rivals, no one says they are being "negative."

The "negative focus" on what's wrong is a survival instinct. As psychologist Albert Maslow's research proved, "Physiological needs such as breathing, food, drink, sleep, sex, expiration, are largely and obviously biological and physical requirements. When they are not fulfilled, people become preoccupied with filling those needs above all else. For example, starving people in a warzone can be oblivious to danger when in search of food."
(Maslow, 1987)

It is important to remember that the human spirit IS a renewable resource.

The impulse to stay encouraged may have led you out the door of your home, and the feeling of rejection may have caused you to hurry right back in. Whether you retreat or reach out, make sure you put that time to good use. If the cheering section is chanting things that discourage you, counter it with your own encouraging self-talk. Remember, there is a link between encouragement and courage! Seek out the company of other Chronic Health Heroes who have gathered wisdom as they have gathered strength. Let's come together and take the edge off of your battle fatigue.

CREATIVE SPARK #22: "RIDERS IN THE STORM"

It's safe to say that blood, also known as "lifeblood," keeps us alive. I can picture a group of ITP patients leaving the conference with the strength of a motorcycle gang, destined for medical facilities where they will demand cutting-edge treatments. By exerting their clout as a group, they are saving their own lives. Being a Chronic Health Hero is an affiliation we can be proud of.

In the Netflix series, *Riverdale*, Jughead belongs to a gang called the Serpents that defend the survival of Riverdale's South Side. They wear leather jackets that have a snake on the back. If all Chronic Health Heroes wore jackets to show how they roll with other "pain slayers," what would it look like? Design a logo for your gang (or coat of arms if you're more of a Renaissance person.)

"You wake up every morning to fight the same demons that left you so tired the night before, and that, my love, is bravery."

-unknown

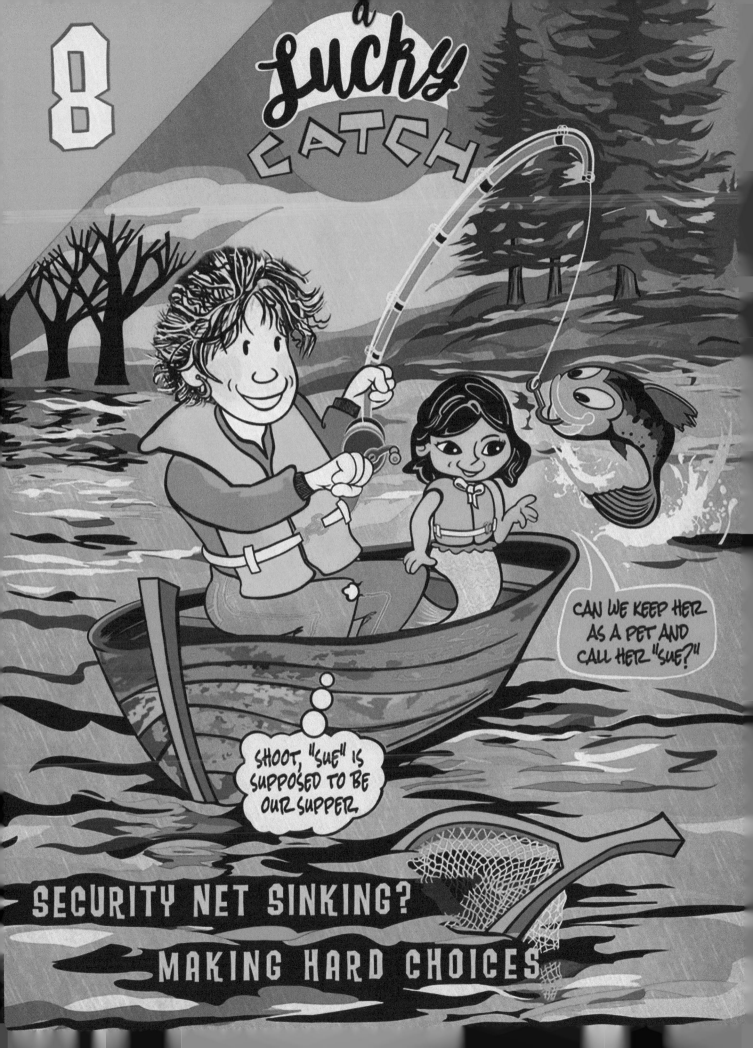

Chapter Eight: A Lucky Catch
Security Net Sinking? Making Hard Choices

"Poverty is the worst form of violence."
-Mahatma Gandhi

If you are sick or disabled, the truth of this quote may ring true, no matter your station in life. Dubbed the John Coltrane and the Mozart of his genre, J. Dilla's obituary on National Public Radio stated that he "was one of the music industry's most influential artists in hip-hop." He was behind countless hits produced by artists like Daft Punk and Janet Jackson. Even fame and fortune couldn't protect him from the financial devastation that can accompany chronic illness.

His mother, Maureen, also a musician and Lupus patient, supported his talent throughout his life, from providing cello lessons to him as a boy, to outfitting his hospital room with recording equipment in his last days. J. Dilla's last album, *Donuts,* was released three days before he died at the age of 32.

There was another deadline, however, that wasn't met. During a hospitalization, J. Dilla was late with an insurance payment, and his insurance was canceled. At a quarter of a million dollars per hospital stay, he was quickly in debt. Maureen sold her home and belongings to help her son maintain his life and his dreams.

J. Dilla had planned to use his wealth to enable poor kids from places like his Detroit neighborhood to learn how to play musical instruments. An opportunistic administrator got the rights to J. Dilla's music while Maureen was preoccupied with saving the star's life, and the family was left with nothing. Even his own children would not be afforded musical instruments from his massive success.

Although J. Dilla was an adult child of Maureen's, he was living proof of an assertion made in the book, *When Children Suffer,* edited by Andrew D. Lester. A chapter about ministering to families whose children have disabilities acknowledged this hard fact: "The constant challenges, both medically and educationally, can easily deplete the resources of the most stable family." While it seems that the above statement would be indisputable, it is too often discounted.

I drew and wrote most of this book in my bed when I wasn't with Alma.

One year, the combined condition-related expenses for Alma and me surpassed my annual income. Yet people expressed puzzlement about my financial lack even though my disability policy, medical doctors, and condition restricted me from working. Even so, when people said they would "give their eye teeth" for their children, I thought it was just a saying—until I had to choose between putting food on the table and seeing a dentist. Sjogren's Syndrome can lead to tooth loss, and my

do-it-yourself extraction effort ended badly. By the time I finally saw my oral surgeon, Dr. Hardy Tuggs, part of my jawbone needed to be removed too.

After paying for those services, I literally did not have enough money to get out of the parking garage, and several cars were lined up behind me. I had a mouth full of bloody gauze, but the parking attendant would not let me through the gate. So I somehow maneuvered my car backward, while the people behind me leaned on their horns. One even flipped me off.

I took the elevator back to the surgeon's office only to find they had left for the day. I searched frantically before finding someone in the nearly deserted medical building willing to validate my parking ticket. Throughout that ordeal, I was just so glad it was not Alma who was waiting to go home after one of her many surgeries.

If only I could have suddenly become like financial author Suze Orman when I was called upon to help provide for two people's disabilities on sixty percent of a teacher's salary. Instead, bone-numbing weariness set in from countless daily encounters like the parking garage incident.

Lucky resisted the urge to call on her mother to help her out of every little jam. Her elderly mom was at an age where most of her peers were receiving support from their grown children, not the other way around. Lucky didn't want her mom's security in her golden years to be further compromised.

Chronic Health Heroes have to be resourceful. One day Lucky Starzinsky was picking up her car from the repair shop when she realized she didn't have enough gas to make it home. When Lucky searched the floor for coins, she spotted the large paper sheet beneath the gas pedal that was used to protect the floorboard. She asked the mechanic if she could have a few more of those sheets which she could use to make drawings to sell. At a dollar or two each, it would only take a few drawings to get Lucky home. But what if she wasn't a sketch artist who could work on the fly?

Getting home is one thing, but keeping a home is another. Long-time hospice nurse Jill lost her health insurance the same day she was unexpectedly laid off as part of corporate downsizing. Unfortunately, her husband Jack, an entrepreneur battling cancer, was on her insurance plan. They had just purchased a tiny trailer to live in temporarily while their dream home on Blue Ridge Hill was being built. Unfortunately, that was one hill that Jack and Jill would never get to climb. Weeks later, that tiny trailer was all they had left. Jack passed away soon after, leaving Jill to start over on her own.

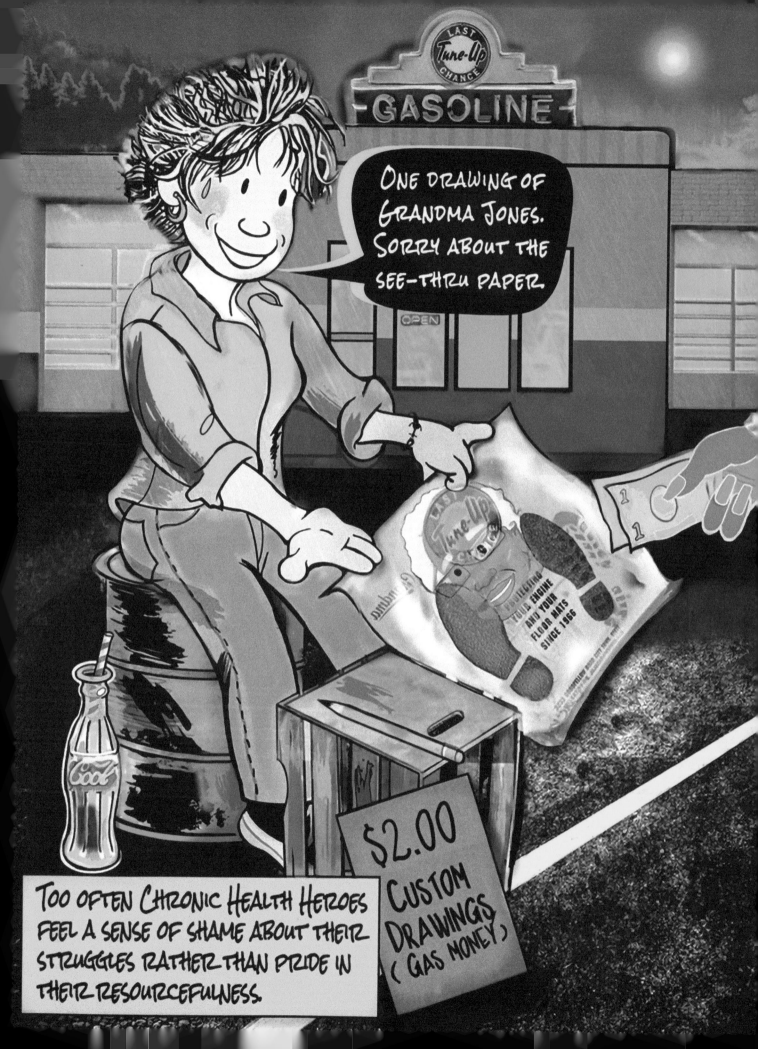

Even private insurance cannot bridge the gap between newly reduced income and the astronomical medical expenses that are not covered. My cousin Houston, who has an Alpha-1 Enzyme deficiency, knows all too well the cost of chronic illness.

There is a chicken-and-egg relationship between medical and financial adversity.

"It's not just the health, it's your freedom, it's being able to support your family, it's your life turned upside down. I never thought I'd be in this position having to figure out what bills to pay, and more importantly, deciding what meds I can get," said Houston.

She continued, "Let's not forget that I have insurance. I have worked since I was 14 and raised two boys single-handedly. Unfortunately, everything changed for me overnight. Any retirement money I had was used for medical bills, and I still owe hundreds of thousands of dollars because my transplant surgery alone cost more than half a million dollars. People need to know how individuals with illness feel, how they are treated differently, and how depression, stress, and anxiety kick in."

What makes the situation harder is the daily chaos that ensues from this kind of strain. Healthy food choices and essential medicines are often out of reach, health insurance teeters on cancellation, utility company deposits are needed to get the gas, water or lights turned back on, and the interest begins to compound along with the pain. Poverty, in short, is physically punishing.

Chronic Health Hero and divorced dad Robin Peter was set to pick up his son at the nursery school, take him to dinner, and return him to his mother's home. He was beginning to feel the effects of going without medicine. Unwilling to miss time with his little boy, he set out to sell scrap metal. By the time he purchased the medicine, Robin had a dollar left and was running on empty in more ways than one.

Hungry and parched, he passed up the snacks and drinks at the convenience store and used the dollar to put gas in his tank. He drove to get a house painting job he had turned down earlier because it went against doctor's orders. When he was finished, he had enough money to feed and transport his son. Robin was so shaky and rushed on the way to pick him up, however, that he failed to fit the lid on the paint can securely, and paint spilled all over his car's interior, a car recently fixed up to sell in order for Robin Peter to pay Paul back for a loan.

As Chronic Health Heroes, we know it sometimes takes a superhuman effort to do seemingly ordinary activities like having dinner with our child or helping an elderly parent manage their affairs. The value of maintaining our bonds is sometimes worth the sacrifice. Don't forget to celebrate the small victories, because they are everything.

There will always be those who believe that disability claims are lazy peoples' plot to escape responsibility, yet there is no faster route **away** from a life of leisure. Once you have used up your savings on care and your earning power is compromised or lost altogether, so are the creature comforts that lend themselves to being considered "together."

Jenna Oxenhandler penned an article in March 2017, *The Guilt of Depending on Someone When You're Chronically Ill*. She wrote that the first time her illnesses made her dependent upon someone else, the person told her she was worthless. She was told she was a liability and should really take better care of herself. The combination of the guilt from not being able to control her symptoms, the side effects of drugs, and needing help, Oxenhandler said, was worse than the illness itself.

On October 13, 2017, the issue of *Lupus News Today* featured research demonstrating that poverty more than doubled the risk of death in Systemic Lupus Erythematosus. "Another important—and stark—finding was that the poor patients who died by 2015 lived almost fourteen years less than the others who died. The implication was that more lupus damage not only leads to a higher risk of death but earlier mortality."

Many of us may also be caretakers for our elderly parents, children, or other loved ones, and our greatest commodity is time and energy. Everyone in our care benefits from our quality of life. Affordable care allows more of us to put our talents and gifts to use, whether as a stay-at-home parent, someone working from home, or one who simply creates a nurturing environment for themselves to live in.

CREATIVE SPARK #23: "SMALL FAVORS"

If you believe the Good Lord (or whatever deity you may honor) has a sense of humor, write a poem or prayer that makes fun of how little it would take to make you feel you had received a "life upgrade."

In spite of everything, sometimes there is a happy ending. Right before J. Dilla died, he took his mother's hands in his and promised his devoted mother that somehow he would make sure everything would be alright. Initially, none of J. Dilla's posthumous royalties were going to his family. Although his mom knew he would have never wanted it that way, she was living in substandard conditions. J. Dilla's promise to his mom, borne of fierce gratitude, that everything would be alright, turned out to be prophetic.

Dear God,
I was walking on the beach the other day when I spied a half-eaten cheese kadoodle in the sand. When you begin to choose between food or medicine, you consider things that wouldn't have crossed your mind before. So I am just glad I wasn't tempted to bend down, pick it up, dust it off, and pop it in my mouth yet. Thank you God for small favors. Amen

Jeff Brubeck owned a vinyl record store, and nearby storage unit managers let him know when someone had abandoned records or cassettes in an unpaid unit. When Brubeck went to check out the latest find, he knew he was sitting on a goldmine. The work belonged to none other than the late, great J. Dilla. The mixtapes were of his earliest unpublished work.

Brubeck did the right thing. He heard the legend's mother and his kids had nothing to show for their beloved one's success. He drove the work straight to J. Dilla's mom and signed the rights over to the deserving matriarch. When she heard her son's voice come alive on the tapes and saw his handwriting on the labels, tears she had held in came pouring out. And somewhere in Heaven, an angel named J. Dilla sang out.

Chapter Nine: Not So Lucky
Law and Disorder? Knowing Your Rights

"I think collectively, we should be paying more attention to what is going on around us in the world among people who don't have the advantages that we have."
-Dr. Anthony Fauci

When I was young, people who couldn't leave home were called "shut-ins" or "invalids," which literally means "not valid." When I embarked on my own journey as a disabled person, I experienced the damaging effects of that negative label first-hand. Many people who become disabled are shocked by how differently they are treated than able-bodied people. That is certainly true in the workplace, whether we are trying to find employment or seek reasonable accommodations in a job we already have.

O. Mitted had applied for a hospital job in social services. He called to find out why he hadn't heard back, and the interviewers explained to him that his application hadn't been processed because they had concerns about whether he could get around in his wheelchair to fulfill the job requirements.

Although O. had no cognitive impairment that would inhibit his ability to do the job, the able-bodied decision-makers clearly didn't value the assets, skills, and unique perspective that O. Mitted had to offer. What made this turn-down especially hurtful was that it was made *by* a department charged with advocacy of the physically challenged *in* a facility designed to be more accessible for wheelchair users. It is difficult not to feel hopeless in the face of such an incomprehensible lack of support.

I got to know O. Mitted because he attended my church, and he was also a social worker at the homeless shelter where I did art ministry. The patients at the hospital where he applied will miss out on his compassionate, engaging advocacy. The administrators did the patients in their care a real disservice.

While some individuals fight to have their invisible conditions recognized at all, people with visible disabilities sometimes find their individuality is eclipsed by their condition.

After teaching children for twenty years, I can honestly say that Alma is one of the most enjoyable kids to be around. Her insights often touch me, and her wit keeps me in stitches. Yet when some people see her wheelchair, they tell me--in front of her--how lucky she is that I adopted her. Hearing this breaks my heart, and hers, repeatedly. Privately admiring a caregiver's commitment is different than implying that the disabled child gives parents any less joy.

"Don't confuse who someone is with their situation."

-K.C. Stanton

People are so much more than their situation, and often, so much more *because* of it, not in *spite* of it. It is when people are defined solely by their minority status, such as "the blind man," "the Jewish lady," "the gay guy," that they are dehumanized.

It's true that my daughter is "the girl in the wheelchair." Alma is also the most tuned-in person I know. She has a remarkably discerning ear whether it is the subtle changes in musical notes or the inflection of a human voice. She is also such a natural teacher, a disciplined athlete, and a graceful dancer. The ramps that allow her to have access to her school also give the school the opportunity to have access to her beautiful mind and heart.

The unwillingness to provide reasonable accommodation implies that people who are disabled are expendable when in fact *every* person is irreplaceable. Accommodations are not just for the sake of the disabled person. They are also designed to protect the community from *missing out* on the gifts that differently-abled individuals can contribute.

Inclusion is not a charitable act, it is mere civility that enriches everyone.

On the other hand, some schools can also be a low-sensitivity zone, sometimes before the person can even get through the door. Parents of a wheelchair-user recounted that the school they toured told them that the fire drill schedule could be compromised by their child's presence. The same couple was told by another school they were considering that the child's wheelchair wouldn't fit with the furniture. Does it make you wonder whether the same would be said to a student in either of those schools who had broken a leg on a ski trip and had to use a wheelchair temporarily?

While the practice of self-care for Chronic Health Heroes is a necessity, this is not always encouraged at work or school. For example, workers can be penalized in their job evaluations for merely having symptoms. For example, needing extra bathroom breaks for Crohn's Disease resulted in a reprimand in a case that was documented in legal journals.

A teacher colleague with diabetes told me she was "written up" for eating snacks to manage her blood sugar levels during her school planning period. We would be right to expect more from schools, and sadly the students sometimes fare worse. Away from the watchful eye of parents, some teachers may regard the accommodations disabled students need as too inconvenient to honor.

Sometimes the problem is more deeply rooted. In October of 2018, FoxBaltimore.com covered a story about a district for having the most alleged cases of disability discrimination in the state. They

interviewed Angelina Davis, a girl whose visual impairment caused her to get headaches when she read. Her request for assignments with larger print was opposed. Angelina said it best, "I think it's mean. It's not fair. If there's something that's going to help, why not just do it?"

The district spokesperson, Pat Answer, issued the following statement prior to the ruling, to let everyone know that they were "devoted to providing every student, including those with educational plans, with a quality education that helps them develop skills beneficial to success as adults."

Because Angelina's family took it up with the Office of Civil Rights, every child in America who is visually impaired is now entitled to large-print materials. I wonder how many of us would guess that such a reasonable universal accommodation was only recently granted in our schools. Fighting the good fight is important. This one family's stance benefitted so many others.

What is even more disturbing in the school setting is the disability harassment some students experience in the classroom. In addition to denying students access to care, teachers sometimes deny elementary and high school-age children protection from verbal and physical intimidation, and in worse case scenarios, teachers unfit to serve in such an important position, join in with mocking and ridiculing behaviors.

Differently-abled students are four times more likely to drop out of school and are left with the hurtful memories of the taunts. This failure perpetuates tolerance for a continued power imbalance throughout a disabled person's life. Although footage of President Donald Trump imitating a physically disabled reporter sparked public outrage, the tolerance for this kind of behavior on some school campuses is the most critical to address. It conditions our young people who are differently-abled to feel they don't deserve the protection afforded to them by the law.

When we are overcome by the acts of bias we experience as adults, we can never forget that differently-abled children rely on us to stand on our shoulders one day. When you speak up on your own behalf, you speak up for us all.

CREATIVE SPARK #24: "ORDER IN THE COURT"

The hardest thing about unfair judgments is how they can seep into our self-concept. Draw a picture of your inner judge. What things does he or she say to you? Does it echo anyone in your life? Add any regular put-downs in word balloons.

When it comes to the job title of parent, the law is not kind to people with disabilities. As of this writing, family law statutes in thirty-seven states consider an able-bodied parent to be a more suitable guardian than one who is disabled. The March/April 2014 issue of GPSOLO, a publication of the American Bar Association (Volume 31, No. 2), by Robyn Powell, Attorney Advisor at the National Council on Disability, states that "Parents with disabilities are the only distinct community of Americans who must struggle to retain or even gain in some situations custody of their children."

In custody battles, a parent generally needs evidence to substantiate claims that their co-parent could jeopardize their child. An exception is made if the harm could come from the co-parent's disability. Given that our legal system was founded on the premise of "innocent until proven guilty," exempting differently-abled people from this protection is flat-out discrimination.

While a child's safety is paramount, the differently-abled parents' self-assessment should not be given less weight than the able-bodied person's, particularly during a potentially contentious divorce. The legitimacy of concerns raised should be verified by the medical professionals who treat the parent in question. Treating the inevitable consequences of adversity as a strike against someone is based on an outdated mindset. Wouldn't it be more productive to search for solutions?

It's undeniable that the loss of physical and fiscal strength that accompanies medical misfortune can impact parenting.

Although parenting is one of the most important jobs in the world, the concept of accommodations is a pretty gray area in family law. Powell's article, quoted above, points out that the court *can* recommend a public entity to provide reasonable accommodations for differently-abled parents.

Sadly lawyers don't always share this information or seek it on behalf of their clients. Although this recommendation is ambiguous, *any* practical help that affords children more and safer access to the love and guidance of their differently-abled parents is a win-win. As it stands, differently-abled people who acknowledge and negotiate for concessions to maximize safety, risk being penalized for such admissions.

Differently-abled parents are also vulnerable to strangers weighing in on their competency as parents. In 2010, a blind couple from Missouri gave birth to a baby girl. The nurse on duty felt their sight impairment made them unfit parents because positioning the infant to breastfeed posed problems for the mother, something that also happens to sighted mothers. Their newborn was placed in state custody. For months, the parents were only able to visit their daughter twice a week for supervised one-hour visits before regaining full custody of their baby girl.

While some might feel breastfeeding is more ideal nutritionally and for bonding purposes, having the bond severed altogether was one nurse's preference. The decision to breastfeed is a personal one. The Office of Women's Health would have told the meddling nurse that new mothers deserve

support no matter how they choose to feed their baby. The nurse could have asked the couple if they wanted the hospital's social services department to provide resources to aid *their* choice to breastfeed. Then again, it might have been the same department that discarded O. Mitted's job application.

"In the absence of justice, we can rely on the power of our imagination."
-Lucky Starzinsky

When personal indignities or systemic unfairness overwhelms us, we can call upon the spirit of our role models to fortify us. The late poet Maya Angelou didn't make it a secret that she imagined certain people accompanied her when she faced a challenging situation. She encouraged her readers to do the same. Some people are such an inspiration that the very thought of them emboldens and empowers us.

When it comes to finding our voice, Angelou is the ultimate authority. She didn't speak for five years after undergoing a trauma as a child and then went on to become the voice of her generation. You also have the option to call upon needed inspiration, anytime, anywhere, by imagining your ideal protector at your side. Think about whose individuals whose presence and ideals would make you feel protected and safe. They can be living or dead, familiar to you, or someone you admire from afar.

For me, one of those people is the Reverend Dr. Martin Luther King, Jr., whom I often paint. In one painting, he is hunched over pen and paper in the Birmingham Jail. I have depicted Jesus standing behind the civil rights leader, His hands-on Dr. King's shoulders. Light streaming from Jesus's heart illuminates the famous letter Dr. King penned in the jail cell in response to white ministers who criticized the timing of his civil disobedience.

I gave the first version of this painting as a gift to a school administrative assistant who was African-American. When she took the artwork home, her eleven-year-old son asked if he could hang it in his room. When she inquired why, he said, "I didn't realize that God was on my side." The boy's statement touched me so deeply I created an entire exhibit featuring Dr. King, which I called "The Road to the Mountaintop." We each have our own mountains to scale, but it helps to remember we don't have to go it alone, if only in our mind's eye.

CREATIVE SPARK #25: "YOU ARE NOT ALONE "

Create an image of yourself with a spiritual companion. Choose a person you either know or know of, and create a collage or drawing of them being your spiritual bodyguard in a distressing situation. By creating a physical representation of that moral support, we tap into a healing state of mind. It is one thing to sense that God is with you or to feel your deceased grandmother is a part of you, but to *see* someone by your side can provide a tangible spirit of support in tough times.

SOME OF THE GREATEST VOICES IN HISTORY WERE NOT ALWAYS HEARD. WHEN HUMAN UNDERSTANDING FALLS SHORT, IT'S NO REFLECTION ON HOW SACRED YOUR LIFE IS.

LETTER FROM THE BIRMINGHAM JAIL

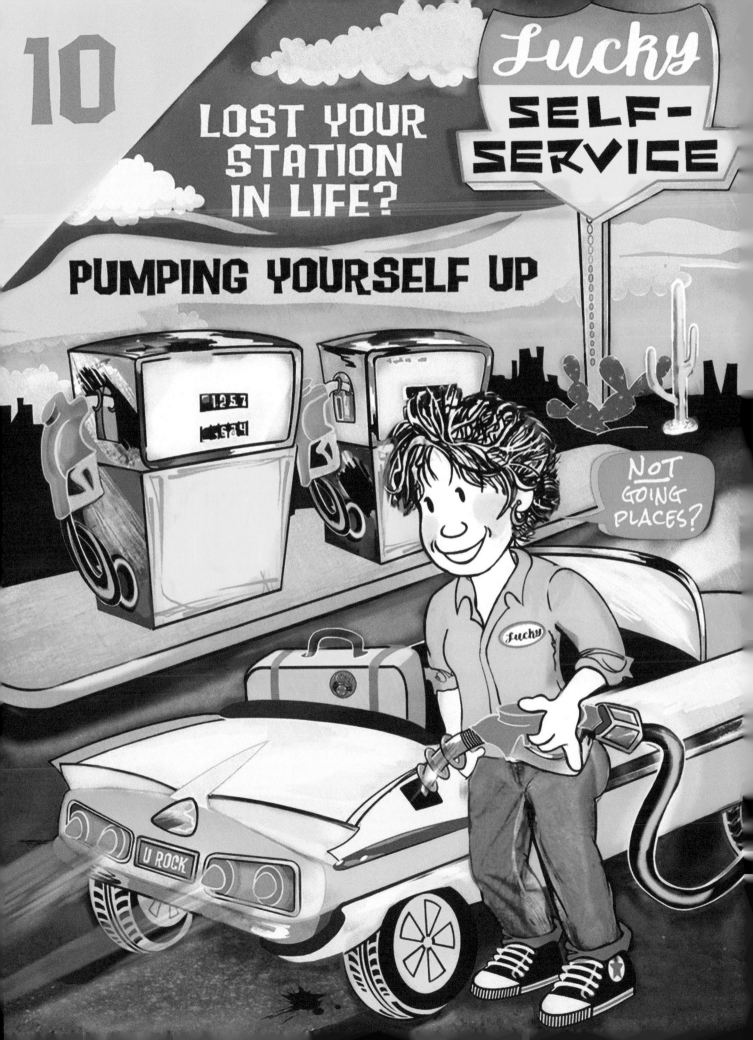

Chapter Ten: Lucky's Self-Service
Lost Your Station in Life? Pumping Yourself Up

In the Netflix series, *Orange Is the New Black*, about a women's prison, inmate Lolly Whitehill is repeatedly victimized for her schizophrenia. First, Lolly loses her job as a journalist, then loses her slot in the group home, and eventually becomes homeless. Ultimately, she is jailed. Just when we think things can't get any worse, Lolly is slated to go to a maximum-security prison.

The night before being transferred, Lolly retreats to a fortified cardboard box she believes to be a time machine. She hopes she can be spared her fate via time travel. Inmate counselor Sam Healy climbs in the makeshift escape to offer Lolly some last-minute advice.

"Lolly," he says, "Everyone wants to go back in time sometimes, to go back to the moment when everything was still possible before they made a wrong turn so that they could go on the right path."

I was reminded of a woman I met at a homeless shelter who still carried all of her old work identification badges from brighter days. She was trying to tell us that she was "somebody" once because people no longer treated her like she was someone who mattered.

CREATIVE SPARK #26: "BEFORE THE FALL"
Draw a picture or write a poem of your life when things were still going right for you.

For some, mental health is the primary chronic challenge being faced, and for others, it may be a secondary challenge arising from the ongoing duress of a physical limitation. Whether mental health conditions are primary or secondary, it can be a stigma. My friend, June Frost, no longer felt as welcome by some of her peers because of her clinical depression. It was June who first taught me that our weaknesses can be a reflection of wear and tear and that it's never a cause for shame. A quote she shared with me below forever empowered me.

"Depression, anxiety, and panic attacks are not signs of weakness. They are signs of trying to remain strong for far too long."
-Anonymous

Kate Jackson wrote a groundbreaking article in the July/August 2014 issue of *Social Work Today* (Vol. 14, No. 4, p. 18) titled, "Grieving Chronic Illness and Injury: Infinite Losses." Jackson points out why it is hard for a patient to find a mindset that allows them to find their emotional stride. Recalling the past brings back memories of what they had to give up, looking to the future is a big question mark. Being in the moment often means feeling trapped in pain or discomfort.

In her article on the same topic, Mila Tecala, LICSW, of the Center for Loss and Grief in Washington, D.C., explains how the loss of vitality "kickstarts a cascade of other forfeitures called 'network losses.'" Both Jackson and Tecala discuss how losses accumulate. The roster of impacted areas consists of the very building blocks of a good life: Career, income, intimacy, sexual function, pride, joy, independence, freedom, hope, dignity, and certainty.

One day, before my daughter read this book, she came to the conclusion that you lose pieces of your life contending with the fallout. Alma Mater added something not mentioned in the scholarly articles on our way to basketball practice one day; that you also lose pieces of yourself.

Kate Jackson does touch upon why, "Although the losses may be vast, the grief they arouse will likely go unrecognized or unaddressed—oversights that can have severe consequences."

Take a moment to appreciate how often we experience these "network losses." You may not have turned paper floor mats into cash, but you have had to be equally resourceful just to afford the tickets for your child's school play or to plan your day to attend a girlfriend's baby shower. It's human nature to measure what you *didn't* get done. Instead, take pride in what you *did* get done. You know how many ways you've had to stretch.

Your health journey has given you certain gifts you wouldn't otherwise possess. With that hard-won wisdom comes abilities, such as listening more closely and giving grace more freely. The pain of being seen as inferior, invisible, or even despised, can teach us about the power of encouragement. Our hardships can also make us more attuned to the oppression of others both in and outside of our minority groups.

CREATIVE SPARK #27: "WHAT'S ON YOUR SHELF?"

Have you been through so much, you could write a book? There is a beautiful saying, "Every time an old person dies, a library burns." That saying is true for a person of any age. There is a collection of books in the library of your soul that contains insights you gained from your life story. On the bookshelf in the next illustration, use a gel pen or paint marker to write titles on the book spines that reflect the stories and wisdom you have to share. To borrow a phrase from former presidential candidate Michael Dukakis, your experiences, good and bad, "enriched and ennobled you." If you wish, on a separate page, write the copy that might go on a book jacket if you were to write an autobiography or self-help book.

Even longstanding anguish can enrich us if we are self-aware. It took me many years to get the upper hand over bitterness and find my center. While crayons, colored pencils, and laughter have been my tools, having a higher calling beyond mere survival has been an anchor too. The hardships you have been through form a "Wisdom Resume" that cannot be found in books, schools, or on the job.

"Are You Living Your Eulogy or Your Resumé?"
-Arianna Huffington

The above quote was the headline of an article written by the founder of the Huffington Post. Here is an excerpt from her article: "Have you noticed that when people die, their eulogies celebrate life very differently from the way we define success in our everyday existence? Eulogies are, in fact, very Third Metric. At HuffPost, we've made the Third Metric -- redefining success beyond money and power to include well-being, wisdom, and our ability to wonder and to give -- a key editorial focus."

Not everyone will embrace this definition of success. Don't be deterred. Once when I was interviewed for a public speaking engagement as an author, the able-bodied interviewer focused on my work-related accomplishments, while dismissing my personal experiences. Unable to depart from her script, she continued to press me for what *professional successes* I could list. The interviewer was unable to value the life experience of seeing my daughter through nineteen surgeries while managing several life-threatening conditions of my own. She didn't see why mourning the passing of twenty-three relatives might arm me with some valuable insights to share.

"When writing the story of your life, don't let anyone else hold the pen."
—Drake

I didn't allow her to dismiss my fortitude or awareness. I decided my interviewer was the one who needed more life experience and that she was not a good fit for me. You have a skill set that you earned at the "School of Hard Knocks" too. *Own it!*

CREATIVE SPARK #28: "YOU DESERVE A MEDAL"

We aren't usually issued a diploma or certificate from the School of Hard Knocks. Design a medal, trophy, or certificate that honors the experiences you have survived, the qualities it required, and the skills you have gained from it. You have a right to be proud.

As months in survival mode turned into years, my ability to cling to the dream of this book was due to teachers who instilled in me a love for vocation. I refused to believe that I was done realizing the fullness of who I could become. My movement toward my goal was barely perceptible, but grieving

the past was a part of that movement. Saying goodbye to the younger version of myself that once occupied the corridors of hospitals and schools helped me be open to a new sense of purpose.

Sometimes an animal can give us the validation that a person withheld. After writing this chapter at a coffeehouse about letting go of my former life, a lizard scurried across my gravel driveway. I appreciate the Native Americans' belief that the Great Mystery sends particular messages through animals who appear on our path or in our dreams. Each animal represents a particular "medicine" to soothe our hearts and our spirits.

According to the Shaman Journey website: "One of the most interesting traits of the lizard is the ability to break off their tails to escape predators. The tail is left behind wriggling, to take the predator's attention off of them while they flee. They are only able to perform this feat *once*, as the new tail that grows to replace the old one, consists of cartilage instead of vertebrae. So they have to choose the moment to let go wisely. Lizard's power lies in the quality of being able to rescue himself from danger by leaving a part of himself behind."

It is only in applying "lizard medicine" that you can truly let go of the past and expand your horizons to include new destinations.

The Great Father above is a shepherd Chief.
I am His and with Him, I want not.
He throws out a rope to me and the name of the rope is love.
He draws me to where the grass is green and the water is not dangerous.
I eat and lie down and am satisfied.
Sometimes my heart is weak and falls down.
He lifts me up again and draws me into a good road.

Excerpt from American Indian Version of The 23rd Psalm
—The Native American Pages of Angelfire.com

Chapter 11 Lucky Treasure
Nearing Rock Bottom? Searching for Purpose

"21. For where your treasure is, there your heart will be also. 22. The eye is the lamp of the body; so then if your eye is clear, your whole body will be full of light."
Matthew 6:21-22 World English Bible

No one knows why bad things happen to good people. There are a lot of theories about how to make meaning out of unfortunate circumstances once they occur. In his book, *The Soul's Code: In Search of Character and Calling,* psychologist James Hillman examines the Greek root of the word for wisdom, "Sophia." Hillman tells us that Sophia had a practical meaning regarding the craft of handling things, like a helmsman steering the boat, "The wise one steers well; the wisdom of making minor adjustments in accord with the accidents of water, wind, and weight."

Hillman proposes that navigating the nightmare moments in our lives propels us toward our purpose and forges our character, even as the crisis seems to pitch us from the helm. Mike Murdock, author of *1,001 Wisdom Keys* and *The Assignment: The Dream & The Destiny,* believes adversity and adversaries are part of defining the problem we were created to solve.

"What grieves you is a clue to something you were assigned to heal."
-Mike Murdock

Both authors propose that the issues that seem to be our greatest hindrance can also serve as a springboard to a new direction. The first step to making room for the next chapter is allowing the last passage to draw to a close. That is easier said than done. Just like the cartoon of Lucky's roommate, the moon who felt disoriented after leaving the sky when his moonlighting position was eliminated, it may seem impossible to imagine a new life. Lost opportunities have to be mourned before we can consider exploring new interests.

CREATIVE SPARK #29: "LIVING MEMORIAL"

Create a memorial to a part of life you left behind to make room for the next phase of your life. It can be a tombstone to designate the part of you that is gone or create a collage to capture the heart of your previous role. Think of it as a visual eulogy for the old you.

I was a public school teacher in my "past life." The school district kicked off every academic year by busing all staff and faculty members from each school to an auditorium that could accommodate us all. Once there, they would try to jolt us out of our complacency with marching bands and keynote speakers.

sunset

I BUILT ROADS OUT FOR MY STUDENTS

ACKNOWLEDGING THE END OF AN ERA IN YOUR LIFE REQUIRES ACCEPTANCE. LIKE ANY LOSS, A CHANCE TO PAY RESPECTS IS PART OF THE PROCESS.

There wasn't much that set apart one assembly from another, except for one keynote speech I've never forgotten. Mrs. Les S. Moore, the Teacher of the Year, asked us to remember how important grown-ups seemed to us when we were students. She reminded us that because we now occupied that same esteemed position, our words had the power to either lift students up or tilt them into chaos.

Then Mrs. Moore went on to share a more personal story. She told us how glad she was, as a little girl when her father left them. It meant the abuse her family suffered at his hands was finally over. Then her mother remarried, and the stepfather started doing things to her that were even worse than being hit. She had no words for his deeds. She only knew that those things made her want to die.

Mrs. Moore, who now taught English, said that the only reason that she hadn't committed suicide was her inability to finish a satisfactory suicide note. Les said no matter how many times she rewrote it, the words were inadequate to express the level of sadness and rage she felt. Her inclinations as a writer literally saved her.

Meanwhile, she was rewriting drafts of poems for her English class. She pulled out one of the poems she turned in to read to us. It started out as a riddle. Something had been stolen from her that she could never get back; although it was no longer in her possession, it was something she would be able to give to her children one day. Les was referring to a childhood. Her teacher wrote in the margins that Les S. Moore would be a fine mother one day.

That was the day that Les began wanting to live again.

Having a greater impact on others isn't always about doing more. Les's teacher didn't become her mentor, adopt her, or sadly contact social services for her. Yet she changed the trajectory of Les's entire life with a sentence. What I most want you to know is that your words also carry tremendous weight. Les changed my ideas about the amount of energy we need to exert to make a difference, and I found comfort in that wisdom when I could no longer stand in front of a blackboard myself.

Your reach is not confined to the desk you once occupied. Your ability to exert influence is not dependent upon standing in front of a podium or even standing at all. You make a difference anytime you provide grace, laughter, or mercy to someone, in person, through social media, in silent prayer, or through a loving glance.

At the heart of all grief is the recognition that something that was sacred and cherished is irrevocably altered in some way. Although it is hard to lose a way of life we hold dear, there is liberation to be

found in loosening our grip and opening our hands to a new way. Keep asking the question, "What's next?" Even if we strain our ears for an answer for months or years to come, we will be living our life as a prayer.

"I never tire of hearing your voice because your words bring life."

-Islam prayer

Chapter 12 Lucky Strikes Again
Are You In a League by Yourself? Building Team Spirit

"There are only four words that mean so much more than I love you, and those words are 'I'm here for you.'"
—sakshi rani

The game of life was designed to be a team sport. Each of us needs teammates who can help us accept inevitable losses and still stay in the game. Most of us have been a part of a team, whether with an actual sports team, coworkers, our family, or our place of worship. If you have retreated from these affiliations, it's time to recruit new players. I'm not suggesting you give up on your current team, but adding kindred spirits to your "bench" will empower you to enjoy the game of life more and improve your mental and physical prowess.

Sebastian Junger has some ideas about the most ideal trait that teammates can share. Junger was a war reporter for fifteen years before realizing that he had Post Traumatic Stress Disorder (PTSD), which prompted him to investigate its effects. Some of his greatest insights came from revisiting research he did on a Navajo reservation as an anthropology major *before* he was immersed in combat.

The ongoing theft and desecration of sacred land is sadly a culturally shared trauma of the Native Americans. However, when Navajo, Apache, and Comanche peoples still had a culture of inter-tribal warfare they did not seem to experience PTSD to the same extent that non-indigenous North Americans did battling other nations.

Unlike warriors in the U.S. military who must assimilate back into civilian life where they are often misunderstood, Junger pointed out in his TED Talk that the Native Americans returned to tribal life where *no explanations were necessary*. He went on to propose that perhaps the rate of PTSD wasn't determined by what happens "out there," but by the way soldiers were received once back on home soil.

"Maybe the problem isn't the vet," Junger said, "maybe the problem is us." The most daunting feelings we Chronic Health Heroes grapple with are not from the health battle itself, but from the negative messages we receive about how we engage in the battle. If you have bemoaned not being understood, it's because mutual understanding acts as an "anti-venom" against traumatizing dismissal.

You may remember my friend, Val Yent, a volunteer for the pulmonary hypertension support group. I asked her how I could be running around with my daughter or a friend one day, and at the hospital unable to breathe, the next. Val, who was already carrying oxygen, explained that we often felt the

impact of our activity on the *next* day. It was a simple piece of information, but the validation shields me from judgment when I go from a period of high energy to utter collapse, I give myself grace. What wisdom can you offer to someone who shares your condition?

"The dragon rises high for all to see. He has become the mentor he has always longed to find."

-Roger Norton and David Miller, *I Ching Empower Tool*

CREATIVE SPARK #30: "HAVE A SEAT"

The Dalai Lama imparts his wisdom from a large leather and wooden chair, custom-designed for his public appearances. Design a special chair, couch, or room where your future self (as early as later today or as far off as next year) shares encouragement with other Chronic Health Heroes. Would you dispense your wisdom from a place that is cozy, tribal, regal?

Most wisdom isn't dispensed from a throne or high office. If Mrs. Moore taught me at the podium the power that one voice can have, it was at children's desks I learned that we may not need to speak at all to make a difference. It was also in those classrooms I learned how much disease can rob us of the chance to share that irreplaceable spirit. Accepting a person as they are doesn't mean we stop combating the disease. It is an important and sometimes lost distinction.

Before becoming a hospital chaplain, I taught at a school affiliated with a local children's hospital for students whose medical conditions could not be met by other special needs departments in the public school system. Sometimes those issues were life-threatening.

The first time one of my students died, I drew a picture of Patrick, the boy who had passed away. His father was too sad to take the painting home. So the portrait hung in a classroom, becoming a makeshift focal point for an impromptu memorial service. It marked the beginning of what was to become a very sad tradition of commemorating our fallen students.

That day also made an indelible mark in my mind. While some adults espoused the usual platitudes, Patrick's classmate Khalil expressed a holy solemnity for his friend. Hand in hand with his teacher, they sat as equals, gazing at the picture of Patrick, with silent tears streaming from their eyes. Although Khalil couldn't physically speak, his eyes shone with an intelligence I would come to rely on later in the year.

They say angels play harps, but I always picture you with your tambourine. It's not hard imagining you as an angel, because to me you already were one. You taught me that we are all made in God's image, endless variations, perfectly unique, like snowflakes, straight from Heaven.

Another student, Zeke, had *walked* into our school at nine years old, staving off the use of crutches as long as he could. By age seventeen, Zeke reluctantly succumbed to using a wheelchair. Zeke and I grew close while producing a musical of *Treasure Island*. Cast to play the part of Billy Bones, he also helped with the script and set designs. The plot twist I did not foresee was the Principal coming to my classroom after school and asking me to sit down. She told me Zeke was dying and that he might not live to be in the play.

Zeke was also sculpting a ship slated to be photographed for the play's program. When I saw that it was becoming hard for Zeke to lift his hands, I shared the concept of art directing with him to prepare for a moment I prayed would never come. I didn't want him to lose ownership of this work. One day Zeke appeared in my doorway to say it was time for him to become the art director. He asked me to finish the sculpture for him. I took the sculpture home and wept before proceeding to do my best to carry out his vision.

Although I had helped able-bodied students compete nationally for college scholarships, seeing the look of pure pride on Zeke's face was the most pivotal moment of my teaching career. Looking back, it was really the instant I was called to my second career as a chaplain. I wrote this poem about Zeke on a train ride home shortly before he lost the battle for his life:

> *The young woman across the aisle on the train tells me she is a fashion design major.*
> *Stacks of papers are scattered across a small pullout tray.*
> *Her ideas flow effortlessly from her mind to pencil to papers filled with long graceful strokes.*
> *Sketches accumulate as she listens to music on her headphones,*
> *It reminds me of the gap between Zeke's mind and his body.*
> *He's an artist, a writer, my brother, my equal*
> *His mind conceives endless visions as rapidly as the scenes that flash by the train window*
> *but no longer expressed through paint or clay. I imagined a conversation with him:*
>
> *"Zeke, the snow outside is beautiful, the trees and fields are covered in white.*
> *And you won't live to see next year's snowfall. I'll be drawing breath after you're gone.*
> *And you're so proud, I don't know how to tell you how brave you are or how much you mean to me…*
> *or how to tell you "goodbye."*
> *We were robbed of the beauty you brought to your art.*
> *So I am determined to live with your uncompromising resolve*
> *I will paint for you, write for you. I'll be your hands.*
> *The musical will be a celebration of what we can express while we are here.*
> *I know that you will be expressing yourself, too, but on a different plane*
> *where I know God is building a studio for you that you will fill with your books and papers,*
> *paint and brushes and the sound of your laughter."*

It was snowing the day we got the news Zeke died. Although I knew his disease could take his life, witnessing Muscular Dystrophy slowly erase him was almost unbearable. I thought I already knew what a wicked thief disease was until I saw it steal from a child. Zeke told me once he wished he could have had a chance to kiss a girl.

Very few students and teachers ventured to school in the ice and snow the day after Zeke died. I wandered restlessly through the halls that day, unable to find solace until Khalil wheeled into my classroom. He came over to sit with me in front of Zeke's portrait. Sliding his hand into mine, Khalil comforted me as no one else could have. He had deep regard for the battle Zeke had fought and a solemn grasp on the preciousness of the life that had been lost. There was an emotional intelligence in Khalil's eyes that conveyed a reverence that needed no words.

While Khalil taught me we are more than enough, Zeke taught me the importance of fighting for what remains. Together they taught me there is a difference between accepting ourselves as we are and reaching for a better life. We don't fight for health to *be* a better person, but to *have* a better life — and that distinction is everything.

Our production of *Treasure Island* was not a *lesser* or diluted version of what "regular kids" could produce. It was simply a different version. The dancers had Cerebral Palsy, the lead singer had Tourette's Syndrome, and the actors had cognitive challenges. Yet, I couldn't imagine a more splendid troupe of actors anywhere.

You only have to watch a production like this or catch a game of wheelchair basketball to learn why we prefer the term "differently-abled," because the *additional* ability — strength, and determination required to perform with daunting limits expresses the limitless bounds of the human spirit.

The lessons I learned from my students came full circle when a special boy and a special girl became a part of my family one summer. Every night when I tucked in Alma Mater and Cory Spondent, I asked them quite sincerely, "How did the best boy *and* the best girl in the whole wide world come to be under my roof?" They would giggle at how stunned I looked each night.

I thought if my children could see how perfect they are, how precious, they would be immune from seeing themselves as less than the whole. We cannot know why some people get sick or injured, sometimes even by other people's hands. I only knew that Alma and Cory didn't deserve to suffer and that I could not have asked for better children.

In case no one has told you lately, you are beautiful and whole. You are deserving of help and comfort. You are not only worth saving, we need you here.

To finish this love letter to fellow Chronic Health Heroes has been my dearest wish. I honor the valor you have shown behind closed doors, I mourn the tears that fell in solitude, and I give thanks for your unique and unrepeatable light. If you ever find that flame is growing dim, I hope you rekindle it by *DRAWING Comfort* in the Creative Spirit that connects us all.

"IN THE DARK NIGHT OF THE SOUL,
BRIGHT FLOWS THE RIVER OF GOD."
—ST. JOHN OF THE CROSS

CPSIA information can be obtained
at www.ICGtesting.com
Printed in the USA
LVHW071352280121
677750LV00018B/119